رَسْمٌ اسْتِشْفَانِي عَلَى آيَاتِ القُرْآنِ

THE TRACING
QUR'ĀN

الجُزْءُ الثَّلَاثِينَ

"كِتَـٰبٌ أَنزَلْنَـٰهُ إِلَيْكَ مُبَـٰرَكٌ لِّيَدَّبَّرُوٓاْ ءَايَـٰتِهِۦ وَلِيَتَذَكَّرَ أُوْلُواْ ٱلْأَلْبَـٰبِ ﴿٢٩﴾"

This is a blessed Book which We have revealed to you O Prophet so that
they may contemplate its verses, and people of reason may be mindful.

[Qur'ān: Ṣād 38:29]

Ibn Daud Books

بِسْمِ اللَّهِ الرَّحْمَٰنِ الرَّحِيمِ

THE TRACING QUR'ĀN

Comments & Suggestions

Allāh ﷻ says, "(The believers pray,) Our Lord! Do not punish us if we
forget or make a mistake." [Al-Baqarah 2:286]

The publisher would appreciate hearing comments and suggestions
from any readers. If you find any errors in this book, these are solely
due to his shortcomings. Please email the author directly and he will
do his best to correct them in the next edition inshā'Allāh.

British Library

A catalogue record for this book is available from the British Library.
www.bl.uk

Publishing

Published by Ibn Daud Books, Leicester, UK and printed by IMAK,
Istanbul, Turkey.

Ibn Daud Books

theauthor@ibndaudbooks.com
www.ibndaudbooks.com
Leicester, UK

ISBN 978-1-8380492-8-7

TABLE OF CONTENTS

The Importance of Engaging with the Qur'ān

Allāh ﷻ says: "The Most Compassionate taught the Qur'ān, created humanity, (and) taught them speech."
[Ar-Raḥmān 55:1-4]

Under this verse Ibn Al-Qayyim ﷺ states that there are three types of bayān (speech/clarification): [Miftāḥ Dār As-Sa'ādah v.2 p.794]

1. Intellectual (Ad-Dhihnī)
2. Oral (Al-Lafẓī)
3. Written (Al-Khaṭṭī/Ar-Rasmī)

These three clarifications each serve the heart, ears and eyes respectively. And humankind must utilise all three in the acquisition of guidance and beneficial knowledge.

Every single time that you or I engage with the Qur'ān is a blessed and beneficial occasion, if the intention is good. No doubt, you will know someone who has capably given you words of wisdom founded on knowledge of the Qur'ān. Equally likely is that someone you know has committed to learning large passages by rote (off by heart). Why are these praiseworthy actions? The basic answer is that they are loved by Allāh ﷻ: He, the Almighty, All-Hearing and All-Seeing has told us repeatedly that the Qur'ān has been sent for people of understanding and contemplation.

Allāh ﷻ says: "Indeed, all will be called to account for (their) hearing, sight, and intellect." [Al-Isrā 17:36]

The Importance of Engaging with the Qur'ān

Allāh ﷻ also criticises those who do not use all three faculties, He ﷻ says:

"(They are wilfully) deaf, dumb and blind so they have no understanding." [Al-Baqarah 2:171]

"Allāh has sealed their hearts and their hearing, and their sight is covered." [Al-Baqarah 2:7]

Therefore, if we are of a mind to be contemplative or just wish to 'switch on' for a minute, we need to sit with the Qur'ān, perhaps to memorise it, to seek accuracy in reciting it, or to draw out its finer meanings: these are all forms of familiarisation, 'getting to know' the Book of Allāh ﷻ. The treasures that we try to draw from this miraculous revelation are to be realised in the fullest way in the next life, the promised Paradise. However, in the 'here and now' and on a human level we can catch sight of many sparkling examples of patient, honest and trustworthy people who have chosen to use the Qur'ān as the beacon which lights their way in this earthly life.

I put it to you that they (our pious predecessors and saintly peers) might have used some slightly unusual method of engagement with the Qur'ān to direct their souls toward a saintly path of improvement. Just as an example, they might have studied with special reverence the verses that related to the tests and trials of the Prophets ﷺ and reflected upon them in relation to their own times of trouble.

The Virtues of Engaging with the Qur'ān by way of Tracing & Writing

The very first verses to be revealed to the Prophet ﷺ also emphasise the use of the pen. Allāh ﷻ says: "Read, (O Prophet,) in the Name of your Lord Who created, created humans from a clinging clot. Read! And your Lord is the Most Generous, Who taught by the pen, taught humanity what they knew not." [Al-Alaq 96:1-5]

Under this verse Ibn Al-Qayyim ﵀ describes the magnitude of the blessing of the pen: Via it knowledge is eternalised, rights are established, bequests are known, testimonies preserved, the calculations of dealings that occur between people can be recorded, the stories of those past are preserved for those present. If there was no writing then the stories of certain eras would be lost to other (later) eras. Tradition would be lost, rulings would be haphazardly applied, the next generation would not know the ways of the predecessors.

So Allāh ﷻ made writing a means of protecting and preserving knowledge from ruin like a container preserves goods from being lost or becoming worthless. Allāh's ﷻ blessing of teaching (writing via) the pen is from His greatest blessings.

He ﷻ is the one who taught writing, so if He ﷻ is the teacher then the action is a desirable action. [Miftāḥ Dār As-Saʿādah v.2 p.792]

My point here is that any route to the Qur'ān should be considered permissible and empowering. In this book, we are putting forward the simple idea of 'tracing' with a pen or pencil. We feel that following every curve and diacritical marking of the words of the Qur'ān in their correct sequence is a rewarding and therapeutic experience.

Tracing, or following the glorious lettering of the Holy Qur'ān, is a very simple way of gaining the pleasure of the Most Merciful ﷻ. We know from the aḥādīth that every letter of the Qur'ān is a blessed creation, and forming each letter in its shape, as intended by Allāh Almighty ﷻ must have a reward, just as every correct reading with the proper 'tajwīd' has a reward.

The Virtues of Engaging with the Qur'ān by way of Tracing & Writing

'Abdullāh ibn Mas'ūd ﷺ narrated that the Prophet ﷺ said: "Whoever recites a letter from Allāh's Book, then he receives the reward from it, and the reward of ten the like of it. I do not say that Alif Lām Mīm is a letter, but Alif is a letter, Lām is a letter and Mīm is a letter." [Jāmi' At-Tirmidhī 2910]

You might already be thinking that a simple copying of the letters, line-by-line, is a little inferior to other interactions with or readings of Qur'ān. After all, the word 'Qur'ān' literally means 'a recitation', yet what we are proposing seems like a 'scribing'. Well, firstly we shouldn't allow small negative thoughts to prevent us from engaging with the Qur'ān. Secondly, there are some clear virtues and justifications for picking up a pen, as seen from the aḥādīth and statements of righteous people.

Abū Hurayrah ﷺ narrated that, when Makkah was conquered, the Prophet ﷺ delivered a sermon. He (Abū Hurayrah ﷺ) said: "A man of the Yemen, who was called Abū Shāh, got up and said: 'O Messenger of Allāh! Write it for me.'" He ﷺ said: "Write it for Abū Shāh." [Ṣaḥīḥ Al-Bukhārī 2434]

This narration shows that the Prophet ﷺ instructed the Companions ﷺ to write down what was said during the sermon in order to preserve it for the Yemeni companion Abū Shāh ﷺ.

Anas ibn Mālik ﷺ used to tell his son: "O my son! Secure knowledge by writing." [Al-Ḥākim 361]

Abū Hurayrah ﷺ narrated that the Messenger of Allāh ﷺ said: " When a man dies, his acts come to an end, but three, recurring charity, or knowledge (by which people) benefit, or a pious son, who prays for him (for the deceased)." [Ṣaḥīḥ Muslim 1631]

This narration outlines the virtue of leaving behind knowledge after one passes away, and what better way to do this than to write it down? Therefore, if we have an opportunity to write verses of the Qur'ān or words from the aḥādīth we should always consider doing so.

The Virtues of Engaging with the Qur'ān by way of Tracing & Writing

Abū Ṣāliḥ Al-Farrā said he asked Ibn Al-Mubārak about the writing of ḥadīth. He (Ibn Al-Mubārak) said, "If it was not for writing, we would not have memorised". [Siyar A'lām An-Nubalā v.8 p.409]

Ar-Rabī' ibn Sulaymān said, "One day Imām As-Shafi'ī walked out and we were gathered so he said to us, 'All of you know this, Allāh have mercy on you all, this knowledge will slip away just like a camel escapes (the rope that binds it), so make (your) books the border fences and (your) pens the shepherds (to protect it).'" [Mukhtasar Tarīkh Dimashq v.21 p.403]

An Approach to Tracing or Writing

I will say it again, then: it is with a small degree of concentration that all-comers can start to access the treasure trove of the wondrous Qur'ān just by copying, tracing, following the forms of the letters. Some people I know have taken this to a most splendid degree: armed with just a pen, and in some cases a stick of bamboo (mimicking a quill) and a bottle of ink, they set course to march the whole way towards success by tracing every letter of the Qur'ān until they reached a point where their collected pages represented a full, personal and beautiful copy of Allāh's ﷻ Book.

Let's work out the mathematics of their effort: there are fifteen lines per page in the most popular edition of the Qur'ān that adorns our shelves in the UK; five lines written each day, taking half an hour each time, will mean that to trace and copy the whole body of the Qur'ān will take a person a fraction over five years. That's not much really, considering the lifelong connection that a person will form with the Book of Allāh ﷻ. Furthermore, what skill they (or you!) will have steadily managed to acquire by following the flow and form of the magnificent Kalām! It will be an individual, personal calligraphic style that can be reproduced in artwork or written form for the sake of gaining Allāh's ﷻ pleasure. That's quite a string to one's bow!

Tracing the words of Allāh's ﷻ Book is a subtly personal and special way of achieving Allāh's ﷻ pleasure. It requires a small but honest degree of sacrifice and concentration. It helps both young and old alike to read reliably, appreciate and understand the same Arabic that has inspired the hearts of millions of people for the last fourteen centuries. It is an act of worship that should be taken seriously and done earnestly.

PROGRESS CHECKLIST

		TRACED	WRITTEN	MEMORISED
SŪRAH AN-NABA'	سُورَةُ النَّبَإِ	☐	☐	☐
SŪRAH AN-NĀZI'ĀT	سُورَةُ النَّازِعَاتِ	☐	☐	☐
SŪRAH 'ABASA	سُورَةُ عَبَسَ	☐	☐	☐
SŪRAH AT-TAKWĪR	سُورَةُ التَّكْوِيرِ	☐	☐	☐
SŪRAH AL-INFIṬĀR	سُورَةُ الانْفِطَارِ	☐	☐	☐
SŪRAH AL-MUṬAFFIFĪN	سُورَةُ المُطَفِّفِينَ	☐	☐	☐
SŪRAH AL-INSHIQĀQ	سورة الإنشقاق	☐	☐	☐
SŪRAH AL-BURŪJ	سُورَةُ البُرُوجِ	☐	☐	☐
SŪRAH AT-ṬĀRIQ	سُورَةُ الطَّارِقِ	☐	☐	☐
SŪRAH AL-A'LĀ	سُورَةُ الأَعْلَى	☐	☐	☐
SŪRAH AL-GHĀSHIYAH	سُورَةُ الغَاشِيَةِ	☐	☐	☐
SŪRAH AL-FAJR	سُورَةُ الفَجْرِ	☐	☐	☐
SŪRAH AL-BALAD	سُورَةُ البَلَدِ	☐	☐	☐
SŪRAH AS-SHAMS	سُورَةُ الشَّمْسِ	☐	☐	☐
SŪRAH AL-LAYL	سُورَةُ اللَّيْلِ	☐	☐	☐
SŪRAH AḌ-ḌUHĀ	سُورَةُ الضُّحَى	☐	☐	☐
SŪRAH AS-SHARH	سُورَةُ الشَّرْحِ	☐	☐	☐
SŪRAH AT-TĪN	سُورَةُ التِّينِ	☐	☐	☐

PROGRESS CHECKLIST

		TRACED	WRITTEN	MEMORISED
SŪRAH AL-'ALAQ	سُورَةُ العَلَقِ	☐	☐	☐
SŪRAH AL-QADR	سُورَةُ القَدْرِ	☐	☐	☐
SŪRAH AL-BAYYINAH	سُورَةُ البَيِّنَةِ	☐	☐	☐
SŪRAH AZ-ZALZALAH	سُورَةُ الزَّلْزَلَةِ	☐	☐	☐
SŪRAH AL-'ĀDIYĀT	سُورَةُ العَادِيَاتِ	☐	☐	☐
SŪRAH AL-QĀRI'AH	سُورَةُ القَارِعَةِ	☐	☐	☐
SŪRAH AT-TAKĀTHUR	سُورَةُ التَّكَاثُرِ	☐	☐	☐
SŪRAH AL-'AṢR	سُورَةُ العَصْرِ	☐	☐	☐
SŪRAH AL-HUMAZAH	سُورَةُ الهُمَزَةِ	☐	☐	☐
SŪRAH AL-FĪL	سُورَةُ الفِيلِ	☐	☐	☐
SŪRAH QURAYSH	سُورَةُ قُرَيْشٍ	☐	☐	☐
SŪRAH AL-MĀ'ŪN	سُورَةُ المَاعُونِ	☐	☐	☐
SŪRAH AL-KAWTHAR	سُورَةُ الكَوْثَرِ	☐	☐	☐
SŪRAH AL-KĀFIRŪN	سُورَةُ الكَافِرُونَ	☐	☐	☐
SŪRAH AN-NAṢR	سُورَةُ النَّصْرِ	☐	☐	☐
SŪRAH AL-MASAD	سُورَةُ المَسَدِ	☐	☐	☐
SŪRAH AL-IKHLĀṢ	سُورَةُ الإِخْلَاصِ	☐	☐	☐
SŪRAH AL-FALAQ	سورة الفلق	☐	☐	☐
SŪRAH AN-NĀS	سُورَةُ النَّاسِ	☐	☐	☐

PRACTICE

			الرَّحِيْم
الرَّحِيْم	الرَّحِيْم	الرَّحِيْم	

			السَّمَاء
السَّمَاء	السَّمَاء	السَّمَاء	

			السَّمٰوٰت
السَّمٰوٰت	السَّمٰوٰت	السَّمٰوٰت	

			جَنَّة
جَنَّة	جَنَّة	جَنَّة	

			جَنَّات
جَنَّات	جَنَّات	جَنَّات	

			النَّار
النَّار	النَّار	النَّار	

			العَلِيْم
العَلِيْم	العَلِيْم	العَلِيْم	

			العَظِيْم
العَظِيْم	العَظِيْم	العَظِيْم	

			رَبّ
رَبّ	رَبّ	رَبّ	

			رَسُوْل
رَسُوْل	رَسُوْل	رَسُوْل	

			مُوْسَىٰ
مُوْسَىٰ	مُوْسَىٰ	مُوْسَىٰ	

			نَفْس
نَفْس	نَفْس	نَفْس	

			قَوْم
قَوْم	قَوْم	قَوْم	

			النَّاس
النَّاس	النَّاس	النَّاس	

PRACTICE

			يُؤْمِنُ
يُؤْمِنُ	يُؤْمِنُ	يُؤْمِنُ	

			الْمُؤْمِن
الْمُؤْمِن	الْمُؤْمِن	الْمُؤْمِن	

			الْمُتَّقِينَ
الْمُتَّقِينَ	الْمُتَّقِينَ	الْمُتَّقِينَ	

			يَكْفُرُ
يَكْفُرُ	يَكْفُرُ	يَكْفُرُ	

			الْكُفْرُ
الْكُفْرُ	الْكُفْرُ	الْكُفْرُ	

			يَظْلِمُ
يَظْلِمُ	يَظْلِمُ	يَظْلِمُ	

			الظَّالِمِ
الظَّالِمِ	الظَّالِمِ	الظَّالِمِ	

			إِيتَاءَ
إِيتَاءَ	إِيتَاءَ	إِيتَاءَ	

			يَعْلَمُ
يَعْلَمُ	يَعْلَمُ	يَعْلَمُ	

			يَعْمَلُ
يَعْمَلُ	يَعْمَلُ	يَعْمَلُ	

			جَاءَ
جَاءَ	جَاءَ	جَاءَ	

			بَعْدَ
بَعْدَ	بَعْدَ	بَعْدَ	

			عِنْدَ
عِنْدَ	عِنْدَ	عِنْدَ	

			لَقَدْ
لَقَدْ	لَقَدْ	لَقَدْ	

سُوْرَةُ النَّبَإِ

بِسْمِ اللهِ الرَّحْمٰنِ الرَّحِيْمِ

In the Name of Allāh, the Gracious, the Merciful

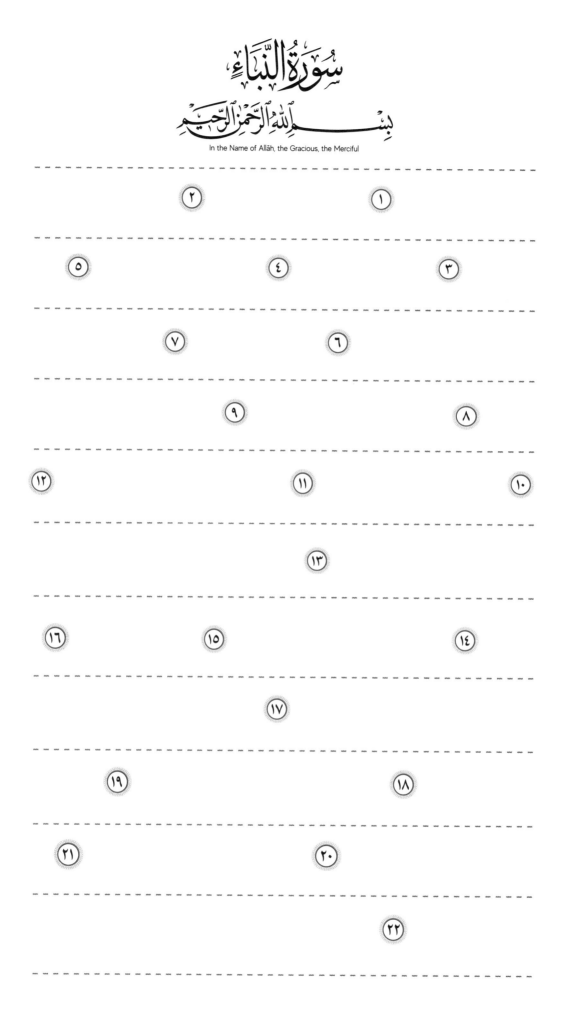

AN-NABA'
(The Momentous News)

In the Name of Allāh, the Gracious,
the Merciful.

سُورَةُ النَّبَإِ

بِسْمِ اللّٰهِ الرَّحْمٰنِ الرَّحِيمِ

In the Name of Allāh, the Gracious, the Merciful

1. What are they asking one
another about?

2. About the momentous news,

3. over which they disagree.

4. But no! They will come to know.

5. Again, no! They will come to
know.

6. Have We not smoothed out the
earth (like a bed),

7. and (made) the mountains as
(its) pegs,

8. and created you in pairs,

9. and made your sleep for rest,

10. and made the night as a cover,

11. and made the day for livelihood,

12. and built above you seven
mighty (heavens),

13. and placed (in them) a shining
lamp,

14. and sent down from
rain-clouds pouring water,

15. producing by it grain and
(various) plants,

16. and dense orchards?

17. Indeed, the Day of (Final)
Decision is an appointed time—

18. (it is) the Day the Trumpet will
be blown, and you will (all) come
forth in crowds.

19. The sky will be (split) open,
becoming (many) gates,

20. and the mountains will be
blown away, becoming (like) a
mirage.

21. Indeed, Hell is lying in ambush

22. as a home for the
transgressors,

فِيهِ هُمُ ٱلَّذِى ② ٱلْعَظِيمِ ٱلنَّبَإِ عَنِ ① يَتَسَآءَلُونَ عَمَّ

concerning it (are) they which (About) the Great the News About are they asking one another About w

أَلَمْ ⑤ سَيَعْلَمُونَ كَلَّا ③ مُخْتَلِفُونَ ④ سَيَعْلَمُونَ كَلَّا ثُمَّ

Have not they will know (soon) Nay Then they will know (soon) Nay disagreement (in

وَخَلَقْنَٰكُمْ ⑦ أَوْتَادًا وَٱلْجِبَالَ ⑥ مِهَٰدًا ٱلْأَرْضَ نَجْعَلِ

And We created you pegs (as) And the mountains a resting place the earth We made

لِبَاسًا ٱلَّيْلَ وَجَعَلْنَا ⑨ سُبَاتًا نَوْمَكُمْ وَجَعَلْنَا ⑧ أَزْوَٰجًا

covering (as) the night And We made rest (for) your sleep And We made pairs (in)

شِدَادًا سَبْعًا فَوْقَكُمْ وَبَنَيْنَا ⑪ مَعَاشًا ٱلنَّهَارَ وَجَعَلْنَا ⑩

strong seven over you And We constructed livelihood (for) the day And We made

مَآءً ٱلْمُعْصِرَٰتِ مِنَ وَأَنزَلْنَا ⑬ وَهَّاجًا سِرَاجًا وَجَعَلْنَا ⑫

water the rain clouds from And We sent down burning a lamp And We placed

أَلْفَافًا وَجَنَّٰتٍ ⑮ وَنَبَاتًا حَبًّا بِهِۦ لِنُخْرِجَ ⑭ ثَجَّاجًا

thick foliage (of) And gardens and vegetation grain thereby That We may bring forth pouring abundan

ٱلصُّورِ فِى يُنفَخُ يَوْمَ ⑰ مِيقَٰتًا كَانَ ٱلْفَصْلِ يَوْمَ إِنَّ

the trumpet in shall be blown (in which) Day (the) an appointed time is the Judgement (of) Day (the) In

وَسُيِّرَتِ ⑲ أَبْوَٰبًا فَكَانَتْ ٱلسَّمَآءُ وَفُتِحَتِ ⑱ أَفْوَاجًا فَتَأْتُونَ

And are moved gateways and becomes the heaven And is opened crowds (in) And is opene

⑳ مِرْصَادًا كَانَتْ جَهَنَّمَ إِنَّ ⑳ سَرَابًا فَكَانَتْ ٱلْجِبَالُ

lying in wait Is Hell Indeed a mirage and become the mountain

مَـَٔابًا لِّلطَّٰغِينَ ㉒

a place of return For the transgress

سُورَةُ النَّبَإِ

AN-NABA'
(The Momentous News)

23. where they will remain for (endless) ages.

24. There they will not taste any coolness or drink,

25. except boiling water and (oozing) pus—

26. a fitting reward.

27. For they never expected any reckoning,

28. and totally rejected Our signs.

29. And We have everything recorded precisely.

30. (So the deniers will be told,) "Taste the punishment, for all you will get from Us is more torment."

31. Indeed, the righteous will have salvation—

32. Gardens, vineyards,

33. and full-bosomed maidens of equal age,

34. and full cups (of pure wine),

35. never to hear any idle talk or lying therein—

36. a (fitting) reward as a generous gift from your Lord,

37. the Lord of the heavens and the earth and everything in between, the Most Compassionate. No one will dare speak to Him

38. on the Day the (holy) spirit and the angels will stand in ranks. None will talk, except those granted permission by the Most Compassionate and whose words are true.

39. That Day is the (ultimate) truth. So let whoever wills take the path leading back to their Lord.

40. Indeed, We have warned you of an imminent punishment—the Day every person will see (the consequences of) what their hands have done, and the disbelievers will cry, "I wish I were dust."

لَّبِثِينَ فِيهَآ أَحْقَابًا ﴿٢٣﴾ لَّا يَذُوقُونَ فِيهَا بَرْدًا وَلَا شَرَابًا ﴿٢٤﴾

be remaining (They) | therein | ages (for) | Not | they will taste | therein | coolness | and not | any drink

إِلَّا حَمِيمًا وَغَسَّاقًا ﴿٢٥﴾ جَزَآءً وِفَاقًا ﴿٢٦﴾ إِنَّهُمْ كَانُوا لَا يَرْجُونَ

Except | scalding water | and purulence | A recompense | appropriate | Indeed, they | were | not | expecting

حِسَابًا ﴿٢٧﴾ وَكَذَّبُوا بِـَٔايَٰتِنَا كِذَّابًا ﴿٢٨﴾ وَكُلَّ شَيْءٍ أَحْصَيْنَٰهُ

an account | And they denied | Our signs | denial (with) | And every | thing | we have enumerated it

كِتَٰبًا ﴿٢٩﴾ فَذُوقُوا فَلَن نَّزِيدَكُمْ إِلَّا عَذَابًا ﴿٣٠﴾ إِنَّ لِلْمُتَّقِينَ

a Book (in) | So taste | and never | We will increase you | except | punishment (in) | Indeed | for the righteous

مَفَازًا ﴿٣١﴾ حَدَآئِقَ وَأَعْنَٰبًا ﴿٣٢﴾ وَكَوَاعِبَ أَتْرَابًا ﴿٣٣﴾ وَكَأْسًا

success (is) | Gardens | and grapevines | And splendid companions | well-matched | And a cup

دِهَاقًا ﴿٣٤﴾ لَّا يَسْمَعُونَ فِيهَا لَغْوًا وَلَا كِذَّٰبًا ﴿٣٥﴾ جَزَآءً مِّن

full | Not | they will hear | therein | any vain talk | and not | any falsehood | (As) a reward | from

رَّبِّكَ عَطَآءً حِسَابًا ﴿٣٦﴾ رَّبِّ ٱلسَّمَٰوَٰتِ وَٱلْأَرْضِ وَمَا

your Lord | a gift | account (according to) | Lord | (of) the heavens | and the earth | and whatever

بَيْنَهُمَا ٱلرَّحْمَٰنِ لَا يَمْلِكُونَ مِنْهُ خِطَابًا ﴿٣٧﴾ يَوْمَ يَقُومُ

between both of them | the Most gracious | not | they have power | from Him | address (to) | Day (The) | will stand

ٱلرُّوحُ وَٱلْمَلَٰٓئِكَةُ صَفًّا لَّا يَتَكَلَّمُونَ إِلَّا مَنْ أَذِنَ لَهُ ٱلرَّحْمَٰنُ

the Spirit | and the Angels | (in) rows | not | they will speak | except | who (one) | permits | him (for) | the Most Gracious

وَقَالَ صَوَابًا ﴿٣٨﴾ ذَٰلِكَ ٱلْيَوْمُ ٱلْحَقُّ فَمَن شَآءَ ٱتَّخَذَ إِلَىٰ

and he (will) say | correct (what is) | That | the Day (is) | and true | So whoever | wills | let him take | towards

رَبِّهِۦ مَئَابًا ﴿٣٩﴾ إِنَّآ أَنذَرْنَٰكُمْ عَذَابًا قَرِيبًا يَوْمَ يَنظُرُ

his Lord | a return | Indeed We | have warned you (We) | a punishment (of) | near | Day (the) | will see

ٱلْمَرْءُ مَا قَدَّمَتْ يَدَاهُ وَيَقُولُ ٱلْكَافِرُ يَٰلَيْتَنِى كُنتُ تُرَٰبًا

the man | what | have sent forth | his hands | and will say | the disbeliever | O I wish | I were | dust

﴿٤٠﴾

سُوْرَةُ النَّازِعَاتِ

بِسْمِ اللهِ الرَّحْمٰنِ الرَّحِيْمِ

In the Name of Allāh, the Gracious, the Merciful

- -

② ①

- -

⑤ ④ ③

- -

⑧ ⑦ ⑥

- -

⑨

- -

⑪ ⑩

- -

⑭ ⑬ ⑫

- -

⑮

- -

⑰ ⑯

- -

⑲ ⑱

- -

㉒ ㉑ ⑳

- -

㉔ ㉓

- -

㉕

- -

AN-NĀZIʿĀT
(Those (Angels) Stripping out (Souls))

In the Name of Allāh, the Gracious,
the Merciful.

In the Name of Allāh, the Gracious, the Merciful

1. By those (angels) stripping out (evil souls) harshly,

2. and those pulling out (good souls) gently,

3. and those gliding (through heavens) swiftly,

4. and those taking the lead vigorously,

5. and those conducting affairs (obediently)!

6. (Consider) the Day (when) the quaking Blast will come to pass,

7. followed by a second Blast.

8. (The deniers') hearts on that Day will be trembling (in horror),

9. with their eyes downcast.

10. (But now) they ask (mockingly), "Will we really be restored to our former state,

11. even after we have been reduced to decayed bones?"

12. Adding, "Then such a return would be a (total) loss (for us)!"

13. But indeed, it will take only one (mighty) Blast,

14. and at once they will be above ground.

15. Has the story of Moses reached you (O Prophet)?

16. His Lord called him in the sacred valley of Ṭuwā,

17. (commanding), "Go to Pharaoh, for he has truly transgressed (all bounds).

18. And say, 'Would you (be willing to) purify yourself,

19. and let me guide you to your Lord so that you will be in awe (of Him)?'"

20. Then Moses showed him the great sign,

21. but he denied and disobeyed (Allāh),

22. then turned his back, striving (against the truth).

23. Then he summoned (his people) and called out,

24. saying, "I am your lord, the most high!"

25. So Allāh overtook him, making him an example in this life and the next.

| swimming | And those who glide | | gently | And those who draw out | | violently | By those who extract |

| will quake | Day (the) | | matter (the) And those who arrange | | a race (in) | And those who race each other |

| will palpitate | that Day | Hearts | the subsequent | Follows it | | the quaking one |

| the former state | to | Indeed be returned | Will we | They say | | humbled | Their eyes |

| losing | a return (would be) then | This | They say | | decayed | bones | we are | What! When |

| Has | awakened (will be) | they | And behold | single | a shout (will be) | it | What! When |

| the sacred | In the valley | his Lord | called him | When | | Musa (of) | story (the) come to you (the |

| you (for) | Would | And say | transgressed (has) Indeed, he | Firaun | to | Go | Tuwa (of |

| Then he showed him | so you would fear | your Lord | to | And i will guide you | | purify yourself | that | to |

| striving | he turned his back | Then | | and disobeyed | But he denied | | the great | the sign |

| Allāh | So seized him | the Most High | your Lord | I am | Then he said | | and called out | And he gathered |

| | | and the first | the last (for) | | and exemplary punishment (wi |

سُورَةُ النَّازِعَاتِ

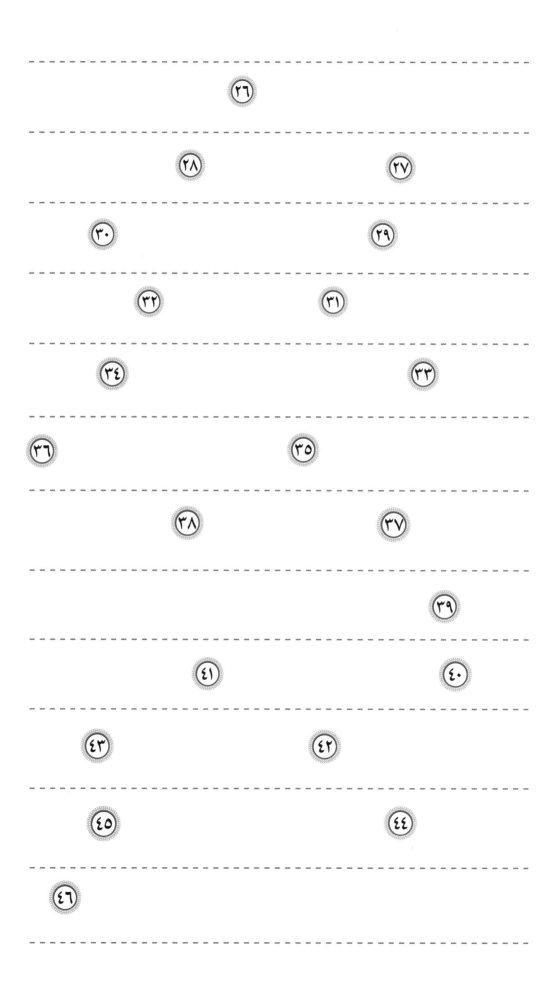

AN-NĀZI'ĀT
(Those (Angels) Stripping out (Souls))

26. Surely in this is a lesson for whoever stands in awe of (Allāh).

27. Which is harder to create: you or the sky? He built it,

28. raising it high and forming it flawlessly.

29. He dimmed its night, and brought forth its daylight.

30. As for the earth, He spread it out as well,

31. bringing forth its water and pastures

32. and setting the mountains firmly (upon it)–

33. all (as a means of) sustenance for you and your animals.

34. But, when the Supreme Disaster comes to pass–

35. the Day every person will remember all (their) striving,

36. and the Hell-fire will be displayed for all to see–

37. then as for those who transgressed

38. and preferred the (fleeting) life of this world,

39. the Hell-fire will certainly be (their) home.

40. And as for those who were in awe of standing before their Lord and restrained themselves from (evil) desires,

41. Paradise will certainly be (their) home.

42. They ask you (O Prophet) regarding the Hour, "When will it be?"

43. But it is not for you to tell its time.

44. That knowledge rests with your Lord (alone).

45. Your duty is only to warn whoever is in awe of it.

46. On the Day they see it, it will be as if they had stayed (in the world) no more than one evening or its morning.

إِنَّ فِى ذَلِكَ لَعِبْرَةً لِّمَن يَخْشَى ٢٦ ءَأَنتُمْ أَشَدُّ خَلْقًا أَمِ

| or | creation | a more difficult | Are you | | fears | for whoever | surely (is)a lesson | that | in | Indeed |

ٱلسَّمَآءُ بَنَىٰهَا ٢٧ رَفَعَ سَمْكَهَا فَسَوَّىٰهَا ٢٨ وَأَغْطَشَ لَيْلَهَا

| its night | And He darkened | | and proportioned it | its ceiling | He raised | | He constructed it | the heaven |

وَأَخْرَجَ ضُحَىٰهَا ٢٩ وَٱلْأَرْضَ بَعْدَ ذَلِكَ دَحَىٰهَآ ٣٠ أَخْرَجَ

| He brought forth | | He spread it | that | after | And the earth | | from it | He brought forth |

مِنْهَا مَآءَهَا وَمَرْعَىٰهَا ٣١ وَٱلْجِبَالَ أَرْسَىٰهَا ٣٢ مَتَٰعًا لَّكُمْ

| for you | a provision (As) | | He made them firm | And the mountains | | and its pasture | its water | from it |

وَلِأَنْعَٰمِكُمْ ٣٣ فَإِذَا جَآءَتِ ٱلطَّآمَّةُ ٱلْكُبْرَىٰ ٣٤ يَوْمَ

| Day (The) | | the great | the Overwhelming Calamity | comes | But when | | and for your cattle |

يَتَذَكَّرُ ٱلْإِنسَٰنُ مَا سَعَىٰ ٣٥ وَبُرِّزَتِ ٱلْجَحِيمُ لِمَن يَرَىٰ ٣٦

| sees | to (him) who | the Hell-fire | And will be made manifest | | he strove (for) | what | man | will remember |

فَأَمَّا مَن طَغَىٰ ٣٧ وَءَاثَرَ ٱلْحَيَوٰةَ ٱلدُّنْيَا ٣٨ فَإِنَّ ٱلْجَحِيمَ هِىَ

| it | the Hell-fire | Then indeed | | the world (of) | the life | And preferred | | transgressed who (him) | Then as for |

ٱلْمَأْوَىٰ ٣٩ وَأَمَّا مَنْ خَافَ مَقَامَ رَبِّهِۦ وَنَهَى ٱلنَّفْسَ عَنِ

| from | his soul | and restrained | his Lord (before) | standing | feared | who (him) | But as for | | the refuge (is) |

ٱلْهَوَىٰ ٤٠ فَإِنَّ ٱلْجَنَّةَ هِىَ ٱلْمَأْوَىٰ ٤١ يَسْـَٔلُونَكَ عَنِ

| about | | They ask you | | the refuge | it (is) | Paradise | Then indeed | | the vain desires |

ٱلسَّاعَةِ أَيَّانَ مُرْسَىٰهَا ٤٢ فِيمَ أَنتَ مِن ذِكْرَىٰهَآ ٤٣ إِلَىٰ

| To | | mention it (to) | of | you (are) | In what | | its arrival (is) | when | the Hour |

رَبِّكَ مُنتَهَىٰهَآ ٤٤ إِنَّمَآ أَنتَ مُنذِرُ مَن يَخْشَىٰهَا ٤٥

| fears it | who (for him) | a warner (are) | You | Only | | its finality (is) | your Lord |

كَأَنَّهُمْ يَوْمَ يَرَوْنَهَا لَمْ يَلْبَثُوٓا۟ إِلَّا عَشِيَّةً أَوْ ضُحَىٰهَا ٤٦

| a morning thereof | or | and evening | except | they had remained | not | they see it | Day (the) | As though they |

سُورَةُ عَبَسَ

بِسْمِ اللَّهِ الرَّحْمَٰنِ الرَّحِيمِ

In the Name of Allāh, the Gracious, the Merciful

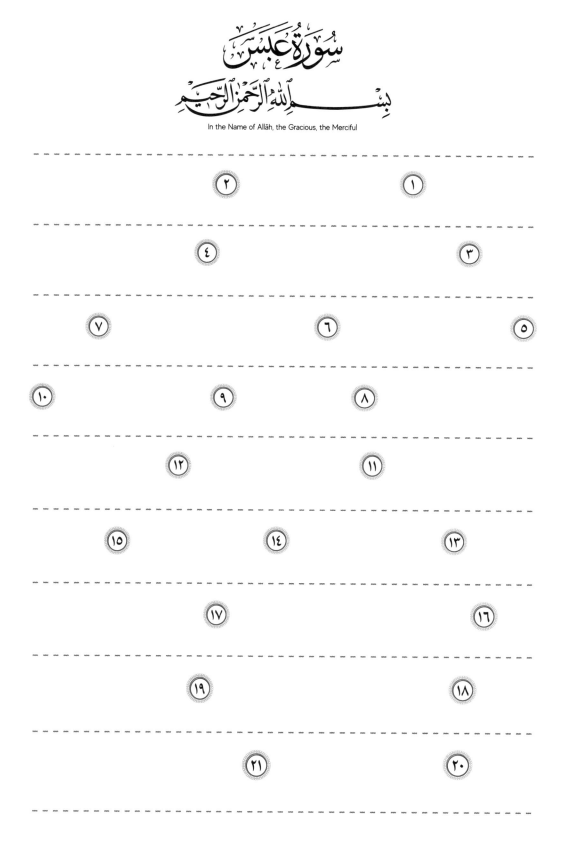

'ABASA
(He Frowned)

In the Name of Allāh, the Gracious, the Merciful.

سُورَةُ عَبَسَ

بِسْمِ اللّٰهِ الرَّحْمٰنِ الرَّحِيمِ

In the Name of Allāh, the Gracious, the Merciful

1. He frowned and turned (his attention) away,

2. (simply) because the blind man came to him (interrupting).

3. You never know (O Prophet), perhaps he may be purified,

4. or he may be mindful, benefiting from the reminder.

5. As for the one who was indifferent,

6. you gave him your (undivided) attention,

7. even though you are not to blame if he would not be purified.

8. But as for the one who came to you, eager (to learn),

9. being in awe (of Allāh),

10. you were inattentive to him.

11. But no! This (revelation) is truly a reminder.

12. So let whoever wills be mindful of it.

13. It is (written) on pages held in honour–

14. highly esteemed, purified–

15. by the hands of angel-scribes,

16. honourable and virtuous.

17. Condemned are (disbelieving) humans! How ungrateful they are (to Allāh)!

18. From what substance did He create them?

19. He created them from a sperm-drop, and ordained their development.

20. Then He makes the way easy for them,

21. then causes them to die and be buried.

that he might	will make you know	But what	the blind man	came to him	Because	and turned away He frown
considers himself free from need	who (him)	As for	the reminder	so would benefit him	be reminded	Or purify hims
But as for	he purifies himself	that not	upon you	And not	give attention	to him So you
distracted (are)	from him	But you		fears	While he	striving came to you So y
sheets	in		may remember it	wills	So whosoever	a reminder (is) Indeed, it Nay
Noble	scribes (of)	In (the)hands	purified	Exalted	honoured	
thing	what	From	ungrateful is he	how	man (the)	is destroyed dutifu
the way	Then	the He proportioned him	He created him	a semen-drop	From	He created hin
and provides a grave for him	He causes him to die	Then	He made easy for			

سُورَةُ عَبَسَ

'ABASA
(He Frowned)

22. Then when He wills, He will resurrect them.

23. But no! They have failed to comply with what He ordered.

24. Let people then consider their food:

25. how We pour down rain in abundance

26. and meticulously split the earth open (for sprouts),

27. causing grain to grow in it,

28. as well as grapes and greens,

29. and olives and palm trees,

30. and dense orchards,

31. and fruit and fodder—

32. all as (a means of) sustenance for you and your animals.

33. Then, when the Deafening Blast comes to pass—

34. on that Day every person will flee from their own siblings,

35. and (even) their mother and father,

36. and (even) their spouse and children.

37. For then everyone will have enough concern of their own.

38. On that Day (some) faces will be bright,

39. laughing and rejoicing,

40. while (other) faces will be dusty,

41. cast in gloom—

42. those are the disbelievers, the (wicked) sinners.

مَّ إِذَا شَاءَ أَنشَرَهُۥ ٢٢ كَلَّا لَمَّا يَقْضِ مَاۤ أَمَرَهُۥ ٢٣

He commanded him what he has accomplished Not Nay He will resurrect him He wills when Th

لْيَنظُرِ ٱلْإِنسَٰنُ إِلَىٰ طَعَامِهِۦٓ ٢٤ أَنَّا صَبَبْنَا ٱلْمَآءَ صَبًّا ٢٥

abundance (in) the water poured (We) That (We) his food at the man Then let loo

شَقَقْنَا ٱلْأَرْضَ شَقًّا ٢٦ فَأَنۢبَتْنَا فِيهَا حَبًّا ٢٧ وَعِنَبًا

And grapes grain therein Then We caused to grow splitting the earth We cleaved Th

قَضْبًا ٢٨ وَزَيْتُونًا وَنَخْلًا ٢٩ وَحَدَآئِقَ غُلْبًا ٣٠ وَفَٰكِهَةً وَأَبًّا

and grass And fruits thick foliage (of) And gardens and date-palms And olive and green fod

مَّتَٰعًا لَّكُمْ وَلِأَنْعَٰمِكُمْ ٣٢ فَإِذَا جَآءَتِ ٱلصَّآخَّةُ ٣٣

the Deafening Blast comes But when and for your cattle for you a provision (As)

مَ يَفِرُّ ٱلْمَرْءُ مِنْ أَخِيهِ ٣٤ وَأُمِّهِۦ وَأَبِيهِ ٣٥ وَصَٰحِبَتِهِۦ

And his wife and his father And his mother his brother from a man will flee Day

نِيهِ ٣٦ لِكُلِّ ٱمْرِئٍ مِّنْهُمْ يَوْمَئِذٍ شَأْنٌ يُغْنِيهِ ٣٧ وُجُوهٌ

Faces occupying him a matter (will be) that Day among them man For every and his chi

يَوْمَئِذٍ مُّسْفِرَةٌ ٣٨ ضَاحِكَةٌ مُّسْتَبْشِرَةٌ ٣٩ وَوُجُوهٌ يَوْمَئِذٍ

that Day And faces rejoicing at good news Laughing bright (will be) that da

لَيْهَا غَبَرَةٌ ٤٠ تَرْهَقُهَا قَتَرَةٌ ٤١ أُوْلَٰٓئِكَ هُمُ ٱلْكَفَرَةُ ٱلْفَجَرَةُ

the wicked ones the disbelievers (are) they Those darkness Will cover them dust (will be) upon th

٤٢

سُورَةُ التَّكْوِيرِ

بِسْمِ اللهِ الرَّحْمَنِ الرَّحِيمِ

In the Name of Allāh, the Gracious, the Merciful

② ①

④ ③

⑥ ⑤

⑨ ⑧ ⑦

⑪ ⑩

⑬ ⑫

⑮ ⑭

AT-TAKWĪR
(Putting out (the Sun))

In the Name of Allāh, the Gracious, the Merciful

In the Name of Allāh, the Gracious,
the Merciful.

1. When the sun is put out,

2. and when the stars fall down,

3. and when the mountains are blown away,

4. and when pregnant camels are left untended,

5. and when wild beasts are gathered together,

6. and when the seas are set on fire,

7. and when the souls (and their bodies) are paired (once more),

8. and when baby girls, buried alive, are asked

9. for what crime they were put to death,

10. and when the records (of deeds) are laid open,

11. and when the sky is stripped away,

12. and when the Hellfire is fiercely flared up,

13. and when Paradise is brought near–

14. (on that Day) each soul will know what (deeds) it has brought along.

15. I do swear by the receding stars

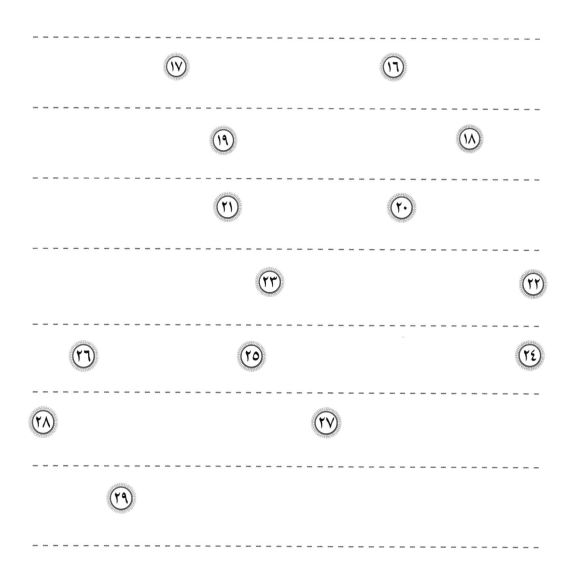

AT-TAKWĪR
(Putting out (the Sun))

16. which travel and hide,

17. and the night as it falls

18. and the day as it breaks!

19. Indeed, this (Qur'ān) is the Word of (Allāh delivered by Gabriel), a noble messenger-angel,

20. full of power, held in honour by the Lord of the Throne,

21. obeyed there (in heaven), and trustworthy.

22. And your fellow man is not insane.

23. And he did see that (angel) on the clear horizon,

24. and he does not withhold (what is revealed to him of) the unseen.

25. And this (Qur'ān) is not the word of an outcast devil.

26. So what (other) path would you take?

27. Surely this (Qur'ān) is only a reminder to the whole world–

28. to whoever of you wills to take the Straight Way.

29. But you cannot will (to do so), except by the Will of Allāh, the Lord of all worlds.

وَٱلصُّبْحِ إِذَا ﴿١٧﴾ وَٱلَّيْلِ إِذَا عَسْعَسَ ﴿١٦﴾ ٱلْجَوَارِ ٱلْكُنَّسِ

| when | And the dawn | | it departs | when | And the night | disappear (and) | Those that r |

ذِي عِندَ ذِي قُوَّةٍ ذِي كَرِيمٍ رَسُولٍ لَّقَوْلُ إِنَّهُۥ ﴿١٨﴾ نفَسَ

| Owner of (the) | with | power | Possessor of | noble | a Messenger (of) | surely a word (is) | Indeed, it | it breathe |

بِمَجْنُونٍ صَاحِبُكُم وَمَا ﴿٢١﴾ أَمِينٍ ثَمَّ مُّطَاعٍ ﴿٢٠﴾ مَّكِينٍ عَرْشِ

| mad | your companion (is) | And not | trustworthy | and | One to be obeyed | secure | the Throne |

بِضَنِينٍ ٱلْغَيْبِ عَلَى هُوَ وَمَا ﴿٢٣﴾ ٱلْمُبِينِ بِٱلْأُفُقِ رَءَاهُ وَلَقَدْ ٢

| a withholder | the unseen | on | he (is) | And not | the clear | in the horizon | he saw him | And certainly |

إِن ﴿٢٦﴾ تَذْهَبُونَ فَأَيْنَ ﴿٢٥﴾ رَّجِيمٍ شَيْطَٰنٍ بِقَوْلِ هُوَ وَمَا ٢٤

| Not | are you going | So where | accursed | Shaitaan (of) | word (is the) | it | And not |

يَسْتَقِيمَ أَن مِنكُمْ شَآءَ لِمَن ﴿٢٧﴾ لِّلْعَٰلَمِينَ ذِكْرٌ إِلَّا هُوَ

| take a straight way | to | among you | wills | For whoever | to the worlds | a reminder | except (is) | it |

ٱلْعَٰلَمِينَ رَبُّ ٱللَّهُ يَشَآءَ أَن إِلَّا تَشَآءُونَ وَمَا ﴿٢٩﴾

| the worlds (of) | Lord | Allāh | wills | that | except | you will | And no |

سُورَةُ الْإِنْفِطَارِ

بِسْمِ اللَّهِ الرَّحْمَٰنِ الرَّحِيمِ

In the Name of Allāh, the Gracious, the Merciful

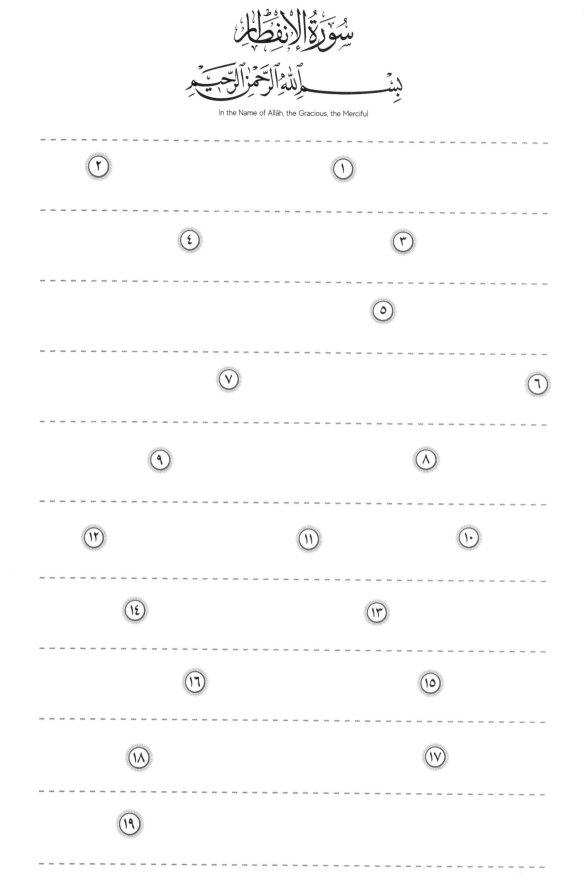

AL-INFIṬĀR
(The (Sky) Splitting Open)

In the Name of Allāh, the Gracious,
the Merciful.

In the Name of Allāh, the Gracious, the Merciful

1. When the sky splits open,

2. and when the stars fall away,

3. and when the seas burst forth,

4. and when the graves spill out,

5. (then) each soul will know what it has sent forth or left behind.

6. O humanity! What has emboldened you against your Lord, the Most Generous,

7. Who created you, fashioned you, and perfected your design,

8. moulding you in whatever form He willed?

9. But no! In fact, you deny the (final) Judgement,

10. while you are certainly observed by vigilant,

11. honourable angels, recording (everything).

12. They know whatever you do.

13. Indeed, the virtuous will be in bliss,

14. and the wicked will be in Hell,

15. burning in it on Judgement Day,

16. and they will have no escape from it.

17. What will make you realize what Judgement Day is?

18. Again, what will make you realize what Judgement Day is?

19. (It is) the Day no soul will be of (any) benefit to another whatsoever, for all authority on that Day belongs to Allāh (entirely).

وَإِذَا ٱلسَّمَآءُ ٱنفَطَرَتْ ﴿١﴾ وَإِذَا ٱلْكَوَاكِبُ ٱنتَثَرَتْ ﴿٢﴾ وَإِذَا

And when ... scatter ... the stars ... And when ... cleft asunder (is) ... the sky ... Wh

ٱلْبِحَارُ فُجِّرَتْ ﴿٣﴾ وَإِذَا ٱلْقُبُورُ بُعْثِرَتْ ﴿٤﴾ عَلِمَتْ نَفْسٌ مَّا

what ... a soul ... Will know ... are overturned ... the graves ... And when ... are made to gush forth ... the seas

قَدَّمَتْ وَأَخَّرَتْ ﴿٥﴾ يَٰٓأَيُّهَا ٱلْإِنسَٰنُ مَا غَرَّكَ بِرَبِّكَ ٱلْكَرِيمِ

the most Noble ... concerning your Lord ... has deceived you ... what ... man ... and left behind ... and left behind ... it has sent

ٱلَّذِي خَلَقَكَ فَسَوَّىٰكَ فَعَدَلَكَ ﴿٧﴾ فِىٓ أَيِّ صُورَةٍ مَّا

what ... form ... whatever ... In ... then balanced you ... then fashioned you ... created you ... Who

شَآءَ رَكَّبَكَ ﴿٨﴾ كَلَّا بَلْ تُكَذِّبُونَ بِٱلدِّينِ ﴿٩﴾ وَإِنَّ عَلَيْكُمْ

over you ... And indeed ... the Judgement ... you deny ... But ... Nay ... He assembled you ... He will

لَحَٰفِظِينَ ﴿١٠﴾ كِرَامًا كَٰتِبِينَ ﴿١١﴾ يَعْلَمُونَ مَا تَفْعَلُونَ ﴿١٢﴾ إِنَّ

Indeed ... you do ... whatever ... They know ... recording ... Noble ... surely guardians

ٱلْأَبْرَارَ لَفِى نَعِيمٍ ﴿١٣﴾ وَإِنَّ ٱلْفُجَّارَ لَفِى جَحِيمٍ ﴿١٤﴾ يَصْلَوْنَهَا

They will burn (in) it ... Hell-fire ... the wicked ... the wicked ... And Indeed ... bliss ... surely in (Will be) ... the righteou

يَوْمَ ٱلدِّينِ ﴿١٥﴾ وَمَا هُمْ عَنْهَا بِغَآئِبِينَ ﴿١٦﴾ وَمَآ أَدْرَىٰكَ مَا

what ... can make you know ... And not ... absent (will be) ... from it ... they ... And not ... the Judgement (of) Day (on

يَوْمُ ٱلدِّينِ ﴿١٧﴾ ثُمَّ مَآ أَدْرَىٰكَ مَا يَوْمُ ٱلدِّينِ ﴿١٨﴾ يَوْمَ لَا

not ... Day (is the) ... the Judgement (of) Day (is the) ... what ... can make you know ... what ... Then ... the Judgement (of) Day (is

تَمْلِكُ نَفْسٌ لِّنَفْسٍ شَيْئًا وَٱلْأَمْرُ يَوْمَئِذٍ لِّلَّهِ ﴿١٩﴾

with Allāh (will be) ... that Day ... and the Command ... anything ... for a soul ... a soul ... will have p

سُورَةُ الْمُطَفِّفِينَ

بِسْمِ اللهِ الرَّحْمٰنِ الرَّحِيمِ

In the Name of Allāh, the Gracious, the Merciful

①

③ ②

⑤ ④

⑦ ⑥

⑩ ⑨ ⑧

⑪

⑫

⑭ ⑬

⑮

⑰ ⑯

⑱

AL-MUṬAFFIFĪN
(Defrauders)

In the Name of Allāh, the Gracious, the Merciful.

سُورَةُ الْمُطَفِّفِينَ

بِسْمِ اللهِ الرَّحْمَنِ الرَّحِيمِ

In the Name of Allāh, the Gracious, the Merciful

1. Woe to the defrauders!

2. Those who take full measure (when they buy) from people,

3. but give less when they measure or weigh for buyers.

4. Do such people not think that they will be resurrected

5. for a tremendous Day–

6. the Day (all) people will stand before the Lord of all worlds?

7. But no! The wicked are certainly bound for Sijjīn (in the depths of Hell)–

8. and what will make you realize what Sijjīn is?–

9. a fate (already) sealed.

10. Woe on that Day to the deniers–

11. those who deny Judgement Day!

12. None would deny it except every evildoing transgressor.

13. Whenever Our revelations are recited to them, they say, "Ancient fables!"

14. But no! In fact, their hearts have been stained by all (the evil) they used to commit!

15. Undoubtedly, they will be sealed off from their Lord on that Day.

16. Moreover, they will surely burn in Hell,

17. and then be told, "This is what you used to deny."

18. But no! The virtuous are certainly bound for ʿIlliyūn in (elevated Gardens)–

① الَّذِينَ إِذَا اكْتَالُوا عَلَى النَّاسِ يَسْتَوْفُونَ

they take in full — the people — from — they take a measure — when — Those who — to those who gives less — Woe

② وَإِذَا كَالُوهُمْ أَوْ وَّزَنُوهُمْ يُخْسِرُونَ ③ أَلَا يَظُنُّ أُولَئِكَ

those — think — Do not — they give less — they weigh (for) them — or — they give by measure (to) them — But when

مَّبْعُوثُونَ ④ لِيَوْمٍ عَظِيمٍ ⑤ يَوْمَ يَقُومُ النَّاسُ لِرَبِّ

before (the) Lord — mankind — will stand — Day (The) — Great — For a Day — resurrected (will be) — that the

الْعَالَمِينَ ⑥ كَلَّا إِنَّ كِتَابَ الْفُجَّارِ لَفِي سِجِّينٍ ⑦ وَمَا أَدْرَاكَ

can make you know — And what — Sijjin — surely in (is) — the wicked (of) — record (the) — Indeed — Nay — the worlds

سِجِّينٌ ⑧ كِتَابٌ مَّرْقُومٌ ⑨ وَيْلٌ يَوْمَئِذٍ لِّلْمُكَذِّبِينَ ⑩

to the deniers — that Day — Woe — written — A book — Sijjin (is) — wh

الَّذِينَ يُكَذِّبُونَ بِيَوْمِ الدِّينِ ⑪ وَمَا يُكَذِّبُ بِهِ إِلَّا كُلُّ

every — except — it (of) — can deny — And not — the Judgement (of) Day (the) — deny — Those w

مُعْتَدٍ أَثِيمٍ ⑫ إِذَا تُتْلَى عَلَيْهِ ءَايَاتُنَا قَالَ أَسَاطِيرُ الْأَوَّلِينَ

the former (people) (of) — Stories — he says — Our Verses — to him — are recited — When — sinful — transgres

⑬ كَلَّا بَلْ رَانَ عَلَى قُلُوبِهِم مَّا كَانُوا يَكْسِبُونَ ⑭ كَلَّا

Nay — earn — they used to — what (for) — their hearts — over — stain has covered (the) — But — Nay

⑮ إِنَّهُمْ عَن رَّبِّهِمْ يَوْمَئِذٍ لَّمَحْجُوبُونَ ⑯ ثُمَّ إِنَّهُمْ لَصَالُوا

will burn (surely) — Indeed, they — Then — surely will be partitioned — that Day — their Lord — from — Indeed, t

الْجَحِيمِ ⑰ ثُمَّ يُقَالُ هَذَا الَّذِي كُنتُم بِهِ تُكَذِّبُونَ

deny — (of it) — you used to — what (is) — This — it will be said — Then — the Hell-fire

⑱ كَلَّا إِنَّ كِتَابَ الْأَبْرَارِ لَفِي عِلِّيِّينَ

illiyin — surely in (will be) — the righteous (of) — record (the) — indeed — Nay

سُورَةُ المُطَفِّفِين

AL-MUṬAFFIFĪN
(Defrauders)

19. and what will make you realize what ʾIlliyūn is?–

20. a fate (already) sealed,

21. witnessed by those nearest (to Allāh).

22. Surely the virtuous will be in bliss,

23. (seated) on (canopied) couches, gazing around.

24. You will recognize on their faces the glow of delight.

25. They will be given a drink of sealed, pure wine,

26. whose last sip will smell like musk. So let whoever aspires to this strive (diligently).

27. And this drink's flavour will come from Tasnīm–

28. a spring from which those nearest (to Allāh) will drink.

29. Indeed, the wicked used to laugh at the believers,

30. wink to one another whenever they passed by,

31. and muse (over these exploits) upon returning to their own people

32. And when they saw the faithful, they would say, "These (people) are truly astray,"

33. even though they were not sent as keepers over the believers.

34. But on that Day the believers will be laughing at the disbelievers,

35. as they sit on (canopied) couches, looking on.

36. (The believers will be asked), "Have the disbelievers (not) been paid back for what they used to do?"

وَمَآ أَدْرَىٰكَ مَا عِلِّيُّونَ ۝ كِتَٰبٌ مَّرْقُومٌ ۝ يَشْهَدُهُ ٱلْمُقَرَّبُونَ ۝

| those brought near | Witness it | written | A book | illiyun (is) | what | can make you know | And wh |

إِنَّ ٱلْأَبْرَارَ لَفِي نَعِيمٍ ۝ عَلَى ٱلْأَرَآئِكِ يَنظُرُونَ ۝

| observing | thrones | On | bliss | surely in (will be) | the righteous | Indeed |

تَعْرِفُ فِي وُجُوهِهِمْ نَضْرَةَ ٱلنَّعِيمِ ۝ يُسْقَوْنَ مِن رَّحِيقٍ

| a pure wine | of | They will be given to drink | bliss (of) | radiance (of) | their faces | in | Indeed |

مَّخْتُومٍ ۝ خِتَٰمُهُۥ مِسْكٌ وَفِي ذَٰلِكَ فَلْيَتَنَافَسِ ٱلْمُتَنَٰفِسُونَ ۝

| the aspirers | let aspire | that | And for | Musk (will be of) | Its seal | sealed |

وَمِزَاجُهُۥ مِن تَسْنِيمٍ ۝ عَيْنًا يَشْرَبُ بِهَا ٱلْمُقَرَّبُونَ ۝

| those brought near | from it | will drink | A spring | Tasnim | of (is) | And its mixture |

إِنَّ ٱلَّذِينَ أَجْرَمُوا۟ كَانُوا۟ مِنَ ٱلَّذِينَ ءَامَنُوا۟ يَضْحَكُونَ ۝

| laugh | believed | those who | at | used to | committed crimes | those who | Inde |

وَإِذَا مَرُّوا۟ بِهِمْ يَتَغَامَزُونَ ۝ وَإِذَا ٱنقَلَبُوٓا۟ إِلَىٰٓ أَهْلِهِمُ

| their people | to | they returned | And when | they winked at one another | by them | they passed | And wh |

ٱنقَلَبُوا۟ فَكِهِينَ ۝ وَإِذَا رَأَوْهُمْ قَالُوٓا۟ إِنَّ هَٰٓؤُلَآءِ لَضَآلُّونَ ۝

| surely have gone astray | these | indeed | they said | they saw them | And when | jesting | they would retu |

وَمَآ أُرْسِلُوا۟ عَلَيْهِمْ حَٰفِظِينَ ۝ فَٱلْيَوْمَ ٱلَّذِينَ ءَامَنُوا۟ مِنَ

| at | believed | those who | So today | guardians (as) | over them | they had been sent | But fr |

ٱلْكُفَّارِ يَضْحَكُونَ ۝ عَلَى ٱلْأَرَآئِكِ يَنظُرُونَ ۝ هَلْ ثُوِّبَ

| been rewarded | Have (not) | observing | the thrones | On | they will laugh | the disbeliev |

ٱلْكُفَّارُ مَا كَانُوا۟ يَفْعَلُونَ ۝

| do | they used to | what (for) | the disbeliev |

سُورَةُ الِانْشِقَاقِ

بِسْمِ اللّٰهِ الرَّحْمٰنِ الرَّحِيمِ

In the Name of Allāh, the Gracious, the Merciful

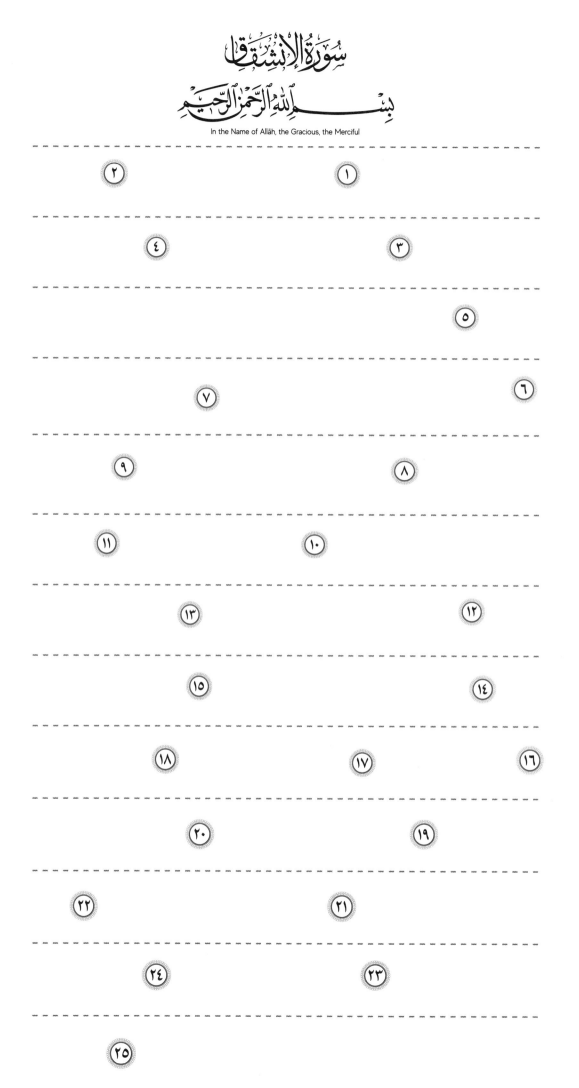

AL-INSHIQĀQ
(The (Sky) Bursting Open)

سُورَةُ الإنْشِقَاقِ

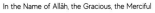

بِسْمِ اللهِ الرَّحْمَنِ الرَّحِيمِ

In the Name of Allāh, the Gracious, the Merciful

In the Name of Allāh, the Gracious, the Merciful.

1. When the sky bursts open,

2. obeying its Lord as it must,

3. and when the earth is flattened out,

4. and ejects (all) its contents and becomes empty,

5. obeying its Lord as it must, (surely you will all be judged).

And when	and was obligated	to its Lord	And has listened	is split asunder	the sky	Wh

6. O humanity! Indeed, you are labouring restlessly towards your Lord, and will (eventually) meet the consequences.

to its Lord	And has listened	and becomes empty	in it (is) what	And has cast out	is spread	the earth

7. As for those who are given their record in their right hand,

and you (will) meet Him	exertion (with)	your Lord	to	labouring (are)	Indeed, you	mankind	O	and was obligat

8. they will have an easy reckoning,

9. and will return to their people joyfully.

his account will be taken	Then soon	in his right (hand)	his record	is given	who (him)	Then as for

10. And as for those who are given their record (in their left hand) from behind their backs,

11. they will cry for (instant) destruction,

who (him)	But as for	happily	his people	to	And he will return	easy	and accou

12. and will burn in the blazing Fire.

And he will burn	destruction (for)	he will call	Then soon	his back	behind	his record	is giv

13. For they used to be prideful among their people,

14. thinking they would never return (to Allāh).

never	that	thought (had)	Indeed, he	happy	his people	among	had been	Indeed, he	a Blaze

15. Yes (they would)! Surely their Lord has always been All-Seeing of them.

by the twilight glow	i swear	But nay	All-Seer	of him	was	his Lord	indeed	Yes	he would

16. So, I do swear by the twilight!

17. And by the night and whatever it envelops!

18. And by the moon when it waxes full!

stage (to)	You will surely embark	it becomes full	when	And the moon	it envelops	and what	And the night

19. You will certainly pass from one state to another.

20. So what is the matter with them that they do not believe,

to them	is recited	And when	they believe	not	for them (is)	So what	stage	from

21. and when the Qur'ān is recited to them, they do not bow down (in submission)?

22. In fact, the disbelievers persist in denial.

And Allāh	deny	disbelieved	Those who	Nay	they prostrate	not	the Qur'ān

23. But Allāh knows best whatever they hide.

24. So give them good news of a painful punishment.

those who	Except	painful	of a punishment	so give them tidings	they keep within themselves	of what	mo knowir

25. But those who believe and do good will have a never-ending reward.

ending	never	a reward (is)	For them	righteous deeds	and do	believe

سُورَةُ البُرُوجِ

بِسْمِ اللهِ الرَّحْمَنِ الرَّحِيمِ

In the Name of Allāh, the Gracious, the Merciful

- -

②　　　　　　　　　①

- -

⑤　　　　　④　　　　　③

- -

⑥

- -

⑧　　　　　　　　　　　⑦

- -

⑨

- -

⑩

- -

⑫　　　　　⑪

- -

⑮　　　　⑭　　　　⑬

- -

⑱　　　⑰　　　⑯

- -

⑳　　　⑲

- -

㉒　　　㉑

AL-BURŪJ
(Constellations)

In the Name of Allāh, the Gracious, the Merciful.

بِسْمِ اللّٰهِ الرَّحْمٰنِ الرَّحِيمِ

In the Name of Allāh, the Gracious, the Merciful

1. By the sky full of constellations,

2. and the promised Day (of Judgement),

3. and the witness and what is witnessed!

وَٱلْيَوْمِ ٱلْمَوْعُودِ ٢ وَشَاهِدٍ

And (the)witness Promised And the Day the constellations containing By the sky

4. Condemned are the makers of the ditch—

5. the fire (pit), filled with fuel—

ٱلنَّارِ ذَاتِ ٱلْوَقُودِ ٤ أَصْحَٰبُ ٱلْأُخْدُودِ ٣ قُتِلَ

the fuel (of) full the fire (of) the pit (of) companion (the) Destroyed were and what is witness

6. when they sat around it,

7. watching what they had (ordered to be) done to the believers,

ذْ هُمْ عَلَيْهَا قُعُودٌ ٦ وَهُمْ عَلَىٰ مَا يَفْعَلُونَ بِٱلْمُؤْمِنِينَ شُهُودٌ

witnesses to the believers they were doing what over And they sitting (were) by it they Wh

8. who they resented for no reason other than belief in Allāh—the Almighty, the Praiseworthy—

وَمَا نَقَمُوا مِنْهُمْ إِلَّا أَن يُؤْمِنُوا بِٱللَّهِ ٱلْعَزِيزِ ٱلْحَمِيدِ ٨

the Praiseworthy the All-Mighty in Allāh they believed that except them (of) they resented And not

9. (the One) to Whom belongs the kingdom of the heavens and earth. And Allāh is a Witness over all things.

ذِي لَهُ مُلْكُ ٱلسَّمَٰوَٰتِ وَٱلْأَرْضِ وَٱللَّهُ عَلَىٰ كُلِّ شَيْءٍ شَهِيدٌ

a Witness (is) thing every on and Allāh and the earth the heavens (of) the dominion (is) for Him The One W

10. Those who persecute the believing men and women and then do not repent will certainly suffer the punishment of Hell and the torment of burning.

إِنَّ ٱلَّذِينَ فَتَنُوا ٱلْمُؤْمِنِينَ وَٱلْمُؤْمِنَٰتِ ثُمَّ لَمْ يَتُوبُوا فَلَهُمْ ٩

then for them they repented not then and the believing women the believing men persecuted those who Indeed

11. Surely those who believe and do good will have Gardens under which rivers flow. That is the greatest triumph.

ذَابُ جَهَنَّمَ وَلَهُمْ عَذَابُ ٱلْحَرِيقِ ١٠ إِنَّ ٱلَّذِينَ ءَامَنُوا وَعَمِلُوا

and do believe those who Indeed the Burning Fire (of) punishment (is the) and for them Hell (of) punishm (is the

12. Indeed, the (crushing) grip of your Lord is severe.

صَّٰلِحَٰتِ لَهُمْ جَنَّٰتٌ تَجْرِي مِن تَحْتِهَا ٱلْأَنْهَٰرُ ذَٰلِكَ ٱلْفَوْزُ

the success (is) That the rivers underneath it from flow Gardens (will be) for them the righteous dee

13. (For) He is certainly the One Who originates and resurrects (all).

14. . And He is the All-Forgiving, All-Loving—

كَبِيرُ ١١ إِنَّ بَطْشَ رَبِّكَ لَشَدِيدٌ ١٢ إِنَّهُ هُوَ يُبْدِئُ وَيُعِيدُ

and repeats originates He Indeed (is) surely strong (is) your Lord (of) Grip (the) Indeed the gre

15. Lord of the Throne, the All-Glorious,

16. Doer of whatever He wills.

وَهُوَ ٱلْغَفُورُ ٱلْوَدُودُ ١٤ ذُو ٱلْعَرْشِ ٱلْمَجِيدُ ١٥ فَعَّالٌ لِّمَا

of what Doer the Glorious the Throne Owner (of) the Most Loving the Oft-Forgiving (is) And He

17. Has the story of the (destroyed) forces reached you (O Prophet)—

18. (the forces of) Pharaoh and Thamūd?

يُدُ ١٦ هَلْ أَتَىٰكَ حَدِيثُ ٱلْجُنُودِ ١٧ فِرْعَوْنَ وَثَمُودَ ١٨ بَلِ

Nay and Thamud Firaun the hosts (of) story (the) come to you Has He inte

19. Yet the disbelievers (still) persist in denial.

20. But Allāh encompasses them from all sides.

ذِينَ كَفَرُوا فِي تَكْذِيبٍ ١٩ وَٱللَّهُ مِن وَرَائِهِم مُّحِيطٌ ٢٠ بَلْ

Nay encompasses behind them from But Allāh denial in (are) Those who Those w

21. In fact, this is a glorious Qur'ān,

22. (Recorded) in a Preserved Tablet.

وَ قُرْءَانٌ مَّجِيدٌ ٢١ فِي لَوْحٍ مَّحْفُوظٍ ٢٢

Guarded a Tablet In Glorious a Qur'ān (is) it

سُورَةُ الطَّلَاقِ

بِسْمِ اللهِ الرَّحْمَنِ الرَّحِيمِ

In the Name of Allāh, the Gracious, the Merciful

AṬ-ṬĀRIQ
(The Nightly Star)

In the Name of Allāh, the Gracious,
the Merciful.

1. By the heaven and the nightly star!

2. And what will make you realize what the nightly star is?

3. (It is) the star of piercing brightness.

4. There is no soul without a vigilant angel (recording everything).

5. Let people then consider what they were created from!

6. (They were) created from a spurting fluid,

7. stemming from between the backbone and the ribcage.

8. Surely He is fully capable of bringing them back (to life)

9. on the Day all secrets will be disclosed.

10. Then one will have neither power nor (any) helper.

11. By the sky with its recurring cycles,

12. and the earth with its sprouting plants!

13. Surely this (Qur'ān) is a decisive word,

14. and is not to be taken lightly.

15. They are certainly devising (evil) plans,

16. but I too am planning.

17. So bear with the disbelievers (O Prophet). Let them be for (just) a little while.

سُورَةُ الطَّارِقِ

بِسْمِ اللَّهِ الرَّحْمَٰنِ الرَّحِيمِ

In the Name of Allāh, the Gracious, the Merciful

the star (it is)	and the night corner (is)	what	can make you know	And what	and the night corner	By the sky
٢ النَّجْمُ		مَا أَدْرَىٰكَ		١ وَمَآ	وَالطَّارِقِ	وَالسَّمَآءِ

So let see	a protector (is)	over it	but	soul	Every (is)	Not	the piercing
٤ فَلْيَنظُرِ	حَافِظٌ	عَلَيْهَا	لَّمَّا	نَفْسٍ	كُلُّ	إِن	٣ الثَّاقِبُ

Coming forth	ejected	a water	from	He is created	his is created	from what	man
يَخْرُجُ	٦ دَافِقٍ	مَّآءٍ	مِن	خُلِقَ	٥ خُلِقَ	مِمَّ	الْإِنسَانُ

Able (is)	return him	to	Indeed, he	and the ribs	the backbone	between	from
لَقَادِرٌ	رَجْعِهِۦ	عَلَىٰ	٧ إِنَّهُۥ	وَالتَّرَآئِبِ	الصُّلْبِ	بَيْنِ	مِنۢ

any helper	and not	power	any	for him (is)	The not	the secrets	will be tested	Day (the)
نَاصِرٍ	وَلَا	قُوَّةٍ	مِن	لَهُۥ	٩ فَمَا	السَّرَآئِرُ	تُبْلَى	٨ يَوْمَ

cracks open	which	And the earth	returns	which	By the sky
الصَّدْعِ	ذَاتِ	١١ وَالْأَرْضِ	الرَّجْعِ	ذَاتِ	١٠ وَالسَّمَآءِ

Indeed, they	for amusement (is)	it	And not	decisive	surely a Word (is)	Indeed, it
١٤ إِنَّهُمْ	بِالْهَزْلِ	هُوَ	وَمَا	١٣ فَصْلٌ	لَقَوْلٌ	١٢ إِنَّهُۥ

the disbelievers (to)	So give respite	a plan	But i am planning	a plot	are plotting
الْكَٰفِرِينَ	فَمَهِّلِ	١٦ كَيْدًا	وَأَكِيدُ	كَيْدًا	يَكِيدُونَ

little	Give respite to th
١٧ رُوَيْدًا	مَهِّلْهُمْ

سُورَةُ الأَعْلَى

بِسْمِ اللَّهِ الرَّحْمَنِ الرَّحِيمِ

In the Name of Allāh, the Gracious, the Merciful

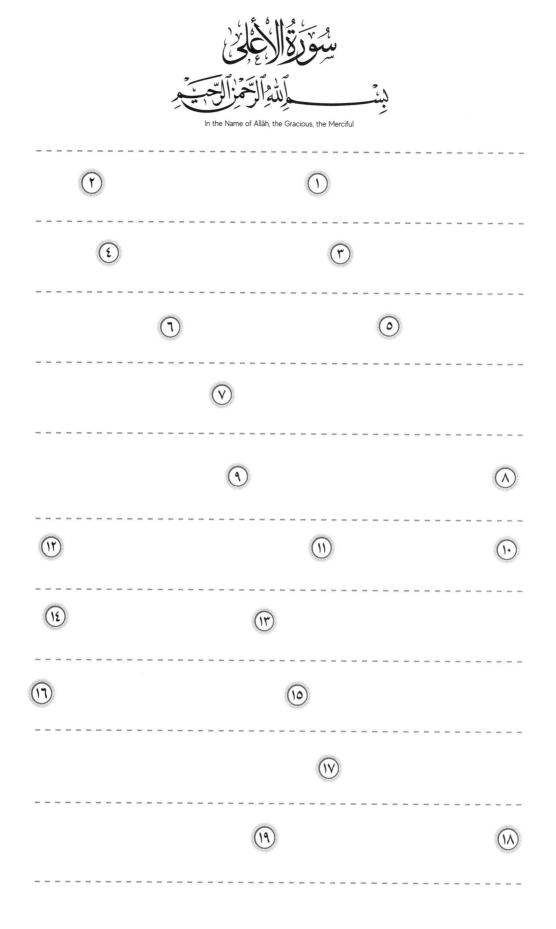

AL-A'LĀ
(The Most High)

In the Name of Allāh, the Gracious, the Merciful.

1. Glorify the Name of your Lord, the Most High,

2. Who created and (perfectly) fashioned (all),

3. and Who ordained precisely and inspired accordingly,

4. and Who brings forth (green) pasture,

5. then reduces it to withered chaff.

6. We will have you recite)the Qur'ān, O Prophet), so you will not forget (any of it),

7. unless Allāh wills otherwise. He surely knows what is open and what is hidden.

8. We will facilitate for you the Way of Ease.

9. So (always) remind (with the Qur'ān)–(even) if the reminder is beneficial (only to some).

10. Those in awe (of Allāh) will be mindful (of it).

11. But it will be shunned by the most wretched,

12. who will burn in the greatest Fire,

13. where they will not (be able to) live or die.

14. Successful indeed are those who purify themselves,

15. remember the Name of their Lord, and pray.

16. But you (deniers only) prefer the life of this world,

17. even though the Hereafter is far better and more lasting.

18. This is certainly (mentioned) in the earlier Scriptures–

19. the Scriptures of Abraham and Moses.

سُوۡرَةُ الاٴعلی

بِسۡمِ ٱللَّهِ ٱلرَّحۡمَٰنِ ٱلرَّحِيمِ

In the Name of Allāh, the Gracious, the Merciful

سَبِّحِ ٱسۡمَ رَبِّكَ ٱلۡأَعۡلَى ١ ٱلَّذِي خَلَقَ فَسَوَّىٰ ٢

then proportioned | created | The One Who | the Most High | your Lord (of) | Name (the) | Glorify

وَٱلَّذِي قَدَّرَ فَهَدَىٰ ٣ وَٱلَّذِي أَخۡرَجَ ٱلۡمَرۡعَىٰ ٤ فَجَعَلَهُ

And then makes it | the pasture | brings forth | And the One who | then guided | measured | And the One who

غُثَآءً أَحۡوَىٰ ٥ سَنُقۡرِئُكَ فَلَا تَنسَىٰ ٦ إِلَّا مَا شَآءَ

wills | what | Except | you will forget | so not | We will make you recite | dark | stubble

ٱللَّهُ إِنَّهُۥ يَعۡلَمُ ٱلۡجَهۡرَ وَمَا يَخۡفَىٰ ٧ وَنُيَسِّرُكَ لِلۡيُسۡرَىٰ

to the ease | And We will ease you | is hidden | and what | the manifest | knows | Indeed, He | Allāh

فَذَكِّرۡ إِن نَّفَعَتِ ٱلذِّكۡرَىٰ ٨ سَيَذَّكَّرُ مَن يَخۡشَىٰ ٩

fears (Allāh) | who (one) | He will pay heed | the reminder | benefits | if | So remind

وَيَتَجَنَّبُهَا ٱلۡأَشۡقَى ١٠ ٱلَّذِي يَصۡلَى ٱلنَّارَ ٱلۡكُبۡرَىٰ ١١

great (the) | the Fire (in) | will burn | The one who | the wretched one | And will avoid it

ثُمَّ لَا يَمُوتُ فِيهَا وَلَا يَحۡيَىٰ ١٢ قَدۡ أَفۡلَحَ مَن تَزَكَّىٰ ١٣

purifies (himself) | who (one) | has succeeded | Certainly | will live | and not | therein | he will die | not | Then

وَذَكَرَ ٱسۡمَ رَبِّهِۦ فَصَلَّىٰ ١٤ بَلۡ تُؤۡثِرُونَ ٱلۡحَيَوٰةَ ٱلدُّنۡيَا ١٥

the world (of) | the life | You prefer | Nay | and prays | his Lord (of) | Name (the) | and remember

وَٱلۡأٓخِرَةُ خَيۡرٌ وَأَبۡقَىٰٓ ١٦ إِنَّ هَٰذَا لَفِي ٱلصُّحُفِ ٱلۡأُولَىٰ ١٧

former (the) | the Scriptures | surely (is)in | this | Indeed | and everlasting | better (is) | While the Hereafter

صُحُفِ إِبۡرَٰهِيمَ وَمُوسَىٰ ١٨

and Musa | Ibrahim (of) | Scriptures (the)

43

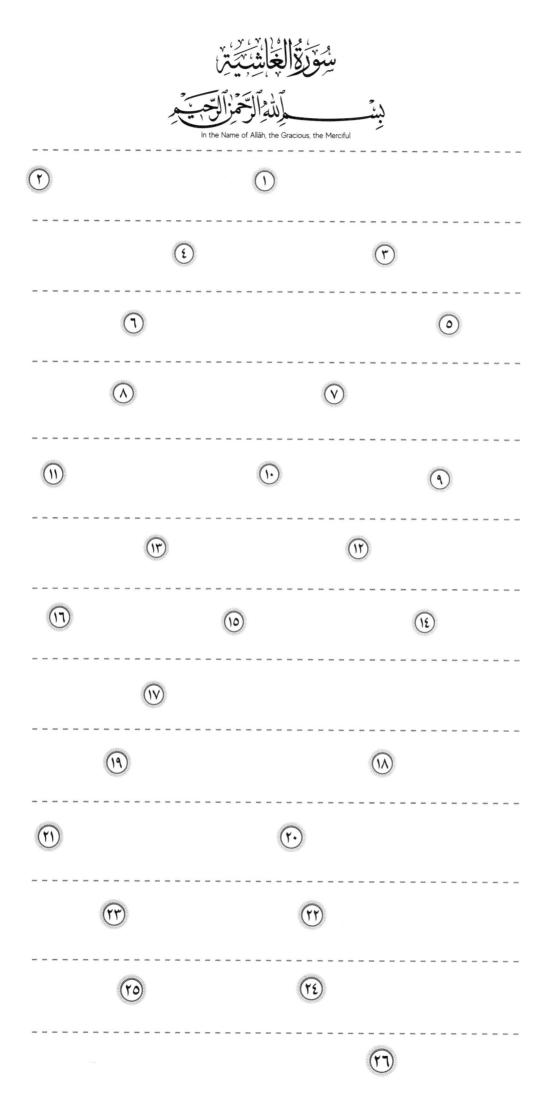

سُورَةُ الغَاشِيَةِ

بِسْمِ اللهِ الرَّحْمٰنِ الرَّحِيمِ

In the Name of Allāh, the Gracious, the Merciful

AL-GHĀSHIYAH
(The Overwhelming Event)

In the Name of Allāh, the Gracious,
the Merciful.

1. Has the news of the Overwhelming Event reached you (O Prophet)?

2. On that Day (some) faces will be downcast,

3. (totally) overburdened, exhausted,

4. burning in a scorching Fire,

5. left to drink from a scalding spring.

6. They will have no food except a foul, thorny shrub,

7. neither nourishing nor satisfying hunger.

8. On that Day (other) faces will be glowing with bliss,

9. (fully) pleased with their striving,

10. in an elevated Garden,

11. where no idle talk will be heard.

12. In it will be a running spring,

13. along with thrones raised high,

14. and cups set at hand,

15. and (fine) cushions lined up,

16. and (splendid) carpets spread out.

17. Do they not ever reflect on camels—how they were (masterfully) created;

18. and the sky—how it was raised (high);

19. and the mountains—how they were firmly set up;

20. and the earth—how it was levelled out?

21. So, (continue to) remind (all, O Prophet), for your duty is only to remind.

22. You are not (there) to compel them (to believe).

23. But whoever turns away, persisting in disbelief,

24. then Allāh will inflict upon them the major punishment.

25. Surely to Us is their return,

26. then surely with Us is their reckoning.

سُورَةُ الْغَاشِيَةِ

بِسْمِ اللهِ الرَّحْمٰنِ الرَّحِيمِ

In the Name of Allāh, the Gracious, the Merciful

هَلْ أَتَىٰكَ حَدِيثُ الْغَٰشِيَةِ ١ وُجُوهٌ يَوْمَئِذٍ خَٰشِعَةٌ ٢

come to you (there) Ha | news (the) | the Overwhelming (of) | Faces | that Day | humbled (will be)

عَامِلَةٌ نَّاصِبَةٌ ٣ تَصْلَىٰ نَارًا حَامِيَةً ٤ تُسْقَىٰ مِنْ عَيْنٍ

Labour | exhausted | They will burn | a Fire (in) | Intensely hot | They will be given to drink | from | a spring

انِيَةٍ ٥ لَّيْسَ لَهُمْ طَعَامٌ إِلَّا مِن ضَرِيعٍ ٦ لَّا يُسْمِنُ

boilin | Not is | for them | for them | a bitter thorny plant | from | except | Not | it nourishes

وَلَا يُغْنِي مِن جُوعٍ ٧ وُجُوهٌ يَوْمَئِذٍ نَّاعِمَةٌ ٨ لِّسَعْيِهَا

and | it avails | from | hunger | Faces | that Day | joyful (will be) | With their effort

ضِيَةٌ ٩ فِي جَنَّةٍ عَالِيَةٍ ١٠ لَّا تَسْمَعُ فِيهَا لَٰغِيَةً ١١

satisfied | In | a garden | elevated | Not | they will hear | therein | vain talk

فِيهَا عَيْنٌ جَارِيَةٌ ١٢ فِيهَا سُرُرٌ مَّرْفُوعَةٌ ١٣ وَأَكْوَابٌ

The | a spring (will be) | flowing | Therein | thrones (will be) | raised high | And cups

مَّوْضُوعَةٌ ١٤ وَنَمَارِقُ مَصْفُوفَةٌ ١٥ وَزَرَابِيُّ مَبْثُوثَةٌ ١٦

put in place | And carpets | lined up | And carpets | spread out

أَفَلَا يَنظُرُونَ إِلَى الْإِبِلِ كَيْفَ خُلِقَتْ ١٧ وَإِلَى السَّمَاءِ

Then d | they look | towards | the camels | how | they are created | And towards | the sky

كَيْفَ رُفِعَتْ ١٨ وَإِلَى الْجِبَالِ كَيْفَ نُصِبَتْ ١٩ وَإِلَى

ho | it is raised | And towards | the mountains | how | they are fixed | And towards

أَرْضِ كَيْفَ سُطِحَتْ ٢٠ فَذَكِّرْ إِنَّمَا أَنتَ مُذَكِّرٌ ٢١

the earth | how | it is spread out | So remind | only | you | are) a reminder (

سْتَ عَلَيْهِم بِمُصَيْطِرٍ ٢٢ إِلَّا مَن تَوَلَّىٰ وَكَفَرَ ٢٣ فَيُعَذِّبُهُ

You are n | over them | a controller | But | whoever | turns away | and disbelieves | Then will punish him

اللهُ الْعَذَابَ الْأَكْبَرَ ٢٤ إِنَّ إِلَيْنَا إِيَابَهُمْ ٢٥ ثُمَّ إِنَّ

Allāh | the punishment (with) | greatest | Indeed | to Us | their return (will be) | Then | indeed

يْنَا حِسَابَهُم ٢٦

upon | their account (is)

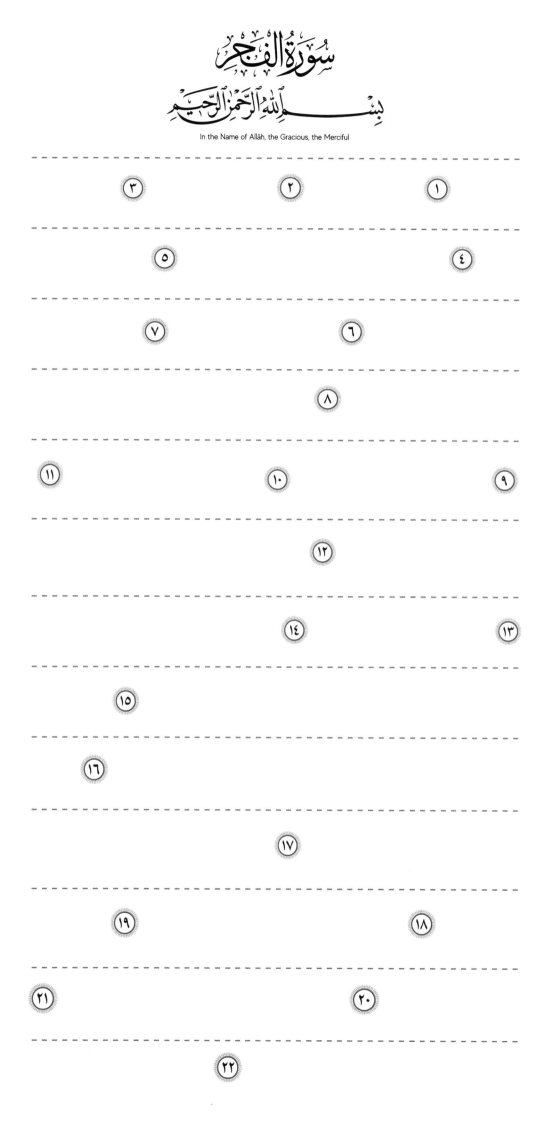

سُورَةُ الفَجْرِ

بِسْمِ اللّٰهِ الرَّحْمٰنِ الرَّحِيمِ

In the Name of Allāh, the Gracious, the Merciful

① ② ③

④ ⑤

⑥ ⑦

⑧

⑨ ⑩ ⑪

⑫

⑬ ⑭

⑮

⑯

⑰

⑱ ⑲

⑳ ㉑

㉒

AL-FAJR
(Dawn)

In the Name of Allāh, the Gracious,
the Merciful.

1. By the dawn,

2. and the ten nights,

3. and the even and the odd,

4. and the night when it passes!

5. Is all this (not) a sufficient oath for those who have sense?

6. Did you not see how your Lord dealt with ʿĀd–

7. (the people) of Iram–with (their) great stature,

8. unmatched in any other land;

9. and Thamūd who carved (their homes into) the rocks in the (Stone) Valley;

10. and the Pharaoh of mighty structures?

11. They all transgressed throughout the land,

12. spreading much corruption there.

13. So your Lord unleashed on them a scourge of punishment.

14. (For) your Lord is truly vigilant.

15. Now, whenever a human being is tested by their Lord through (His) generosity and blessings, they boast, "My Lord has (deservedly) honoured me!"

16. But when He tests them by limiting their provision, they protest, "My Lord has (undeservedly) humiliated me!"

17. Absolutely not! In fact, you are not (even) gracious to the orphan,

18. nor do you urge one another to feed the poor.

19. And you devour (others) inheritance greedily,

20. and love wealth fervently.

21. Enough! When the earth is entirely crushed over and over,

22. and your Lord comes (to judge) with angels, rank upon rank,

سُورَةُ الْفَجْرِ

AL-FAJR
(Dawn)

23. and Hell is brought forth on that Day—this is when every (disbelieving) person will remember (their own sins). But what is the use of remembering then?

24. They will cry, "I wish I had sent forth (something good) for my (true) life."

25. On that Day He will punish (them) severely, like no other,

26. and bind (them) tightly, like no other.

27. (Allāh will say to the righteous), "O tranquil soul!

28. Return to your Lord, well pleased (with Him) and well pleasing (to Him).

29. So join My servants,

30. and enter My Paradise."

وَجِائَ يَوْمَئِذٍ بِجَهَنَّمَ يَوْمَئِذٍ يَتَذَكَّرُ ٱلْإِنسَنُ وَأَنَّىٰ لَهُ

for him (will be) | but how | man | will remember | That Day | Hell | that Day | And is brough

ٱلذِّكْرَىٰ ﴿٢٣﴾ يَقُولُ يَلَيْتَنِي قَدَّمْتُ لِحَيَاتِي ﴿٢٤﴾ فَيَوْمَئِذٍ

So that Day | for my life | I had sent forth | O I wish | He will say | the remembranc

يُعَذِّبُ عَذَابَهُۥ أَحَدٌ ﴿٢٥﴾ وَلَا يُوثِقُ وَثَاقَهُۥٓ أَحَدٌ ﴿٢٦﴾

anyone | His binding (as) | will bind | And not | anyone | His punishment (as) | will punish

يَٰٓأَيَّتُهَا ٱلنَّفْسُ ٱلْمُطْمَئِنَّةُ ﴿٢٧﴾ ٱرْجِعِي إِلَىٰ رَبِّكِ رَاضِيَةً

well pleased | your Lord | to | Return | who is satisfied | soul | O

رَّضِيَّةً ﴿٢٨﴾ فَٱدْخُلِي فِي عِبَٰدِي ﴿٢٩﴾ وَٱدْخُلِي جَنَّتِي ﴿٣٠﴾

My paradise | And enter | My slaves | among | So enter | and pleasing

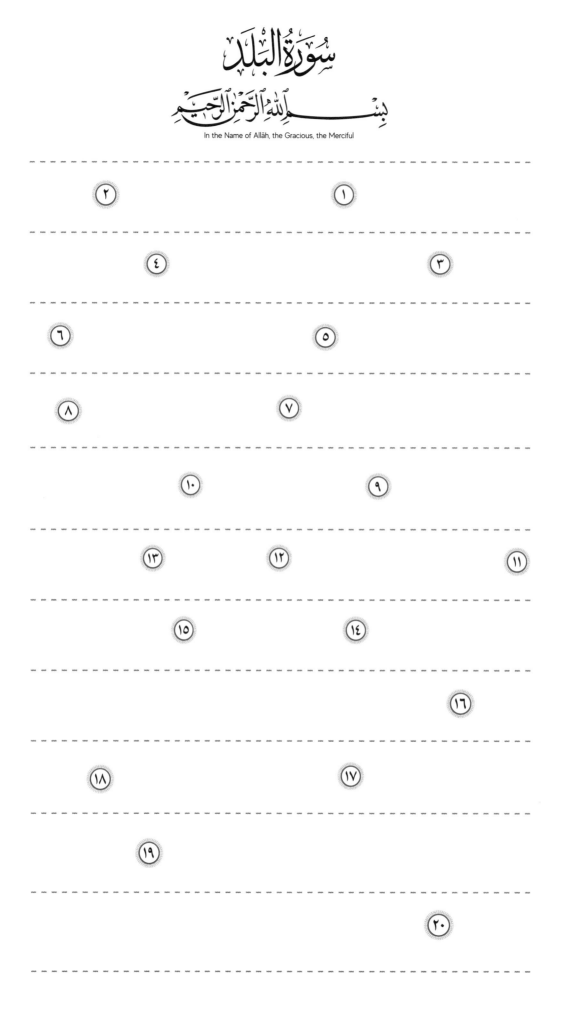

سُورَةُ البَلَدِ

بِسْمِ اللّٰهِ الرَّحْمٰنِ الرَّحِيمِ

In the Name of Allāh, the Gracious, the Merciful

AL-BALAD
(The City)

سُورَةُ الْبَلَد

بِسْمِ اللَّهِ الرَّحْمَٰنِ الرَّحِيمِ

In the Name of Allāh, the Gracious, the Merciful

In the Name of Allāh, the Gracious,
the Merciful.

1. I do swear by this city (of Mecca)–

2. even though you (O Prophet) are subject to abuse in this city–

3. and by every parent and (their) child!

4. Indeed, We have created humankind in (constant) struggle.

5. Do they think that no one has power over them,

6. boasting, "I have wasted enormous wealth!"?

7. Do they think that no one sees them?

8. Have We not given them two eyes,

9. a tongue, and two lips;

10. and shown them the two ways (of right and wrong)?

11. If only they had attempted the challenging path (of goodness instead)!

12. And what will make you realize what (attempting) the challenging path is?

13. It is to free a slave;

14. or to give food in times of famine

15. to an orphaned relative

16. or to a poor person in distress

17. and–above all–to be one of those who have faith and urge each other to perseverance and urge each other to compassion.

18. These are the people of the right.

19. As for those who deny Our signs, they are the people of the left.

20. The Fire will be sealed over them.

وَوَالِدٍ ② بِهَٰذَا الْبَلَدِ وَأَنتَ حِلٌّ بِهَٰذَا الْبَلَدِ ① لَا أُقْسِمُ

Nay | I swear | by this | city | And you (are) free (to dwell) | in this | city | And the begetter

أَن ④ لَقَدْ خَلَقْنَا الْإِنسَانَ فِي كَبَدٍ ③ وَمَا وَلَدَ

and whom he begot | Certainly | We have created | man | in (to be) | hardship | Does he think | that

لَّن يَقْدِرَ عَلَيْهِ أَحَدٌ ⑤ يَقُولُ أَهْلَكْتُ مَالًا لُّبَدًا ⑥

not | has power | over him | anyone | He will say | I have squandered | wealth | abundant

أَيَحْسَبُ أَن لَّمْ يَرَهُ أَحَدٌ ⑦ أَلَمْ نَجْعَل لَّهُ عَيْنَيْنِ ⑧

Does he think | that | not | sees him | anyone | Have not | We made | for him | two eyes

وَلِسَانًا وَشَفَتَيْنِ ⑨ وَهَدَيْنَاهُ النَّجْدَيْنِ ⑩ فَلَا اقْتَحَمَ الْعَقَبَةَ

And a tongue | and two lips | And shown him | the two ways | But not | he has attempted | the steep path

⑪ وَمَا أَدْرَاكَ مَا الْعَقَبَةُ ⑫ فَكُّ رَقَبَةٍ ⑬ أَوْ إِطْعَامٌ فِي

And what | can make you know | what | the steep path (is) | freeing (it is) | a neck | Or | feeding | in

يَوْمٍ ذِي مَسْغَبَةٍ ⑭ يَتِيمًا ذَا مَقْرَبَةٍ ⑮ أَوْ مِسْكِينًا ذَا

a day | of | severe hunger | An orphan | of | near relationship | Or | a needy person | in

مَتْرَبَةٍ ⑯ ثُمَّ كَانَ مِنَ الَّذِينَ ءَامَنُوا وَتَوَاصَوْا بِالصَّبْرِ

misery | Then | he is | of | those whose | believe | and enjoing (each other) | to patience

وَتَوَاصَوْا بِالْمَرْحَمَةِ ⑰ أُولَٰئِكَ أَصْحَابُ الْمَيْمَنَةِ ⑱

and enjoing (each other) | to compassion | Those | (are the) companions | (of) the right (hand)

وَالَّذِينَ كَفَرُوا بِآيَاتِنَا هُمْ أَصْحَابُ الْمَشْأَمَةِ ⑲ عَلَيْهِمْ نَارٌ

But those who | disbelieve | in Our Verses | they | (are the) companions | (of) the left (hand) | Over them | Fire (will be the)

مُّؤْصَدَةٌ ⑳

closed in

سُوْرَةُ الشَّمْسِ

بِسْمِ اللّٰهِ الرَّحْمٰنِ الرَّحِيْمِ

In the Name of Allāh, the Gracious, the Merciful

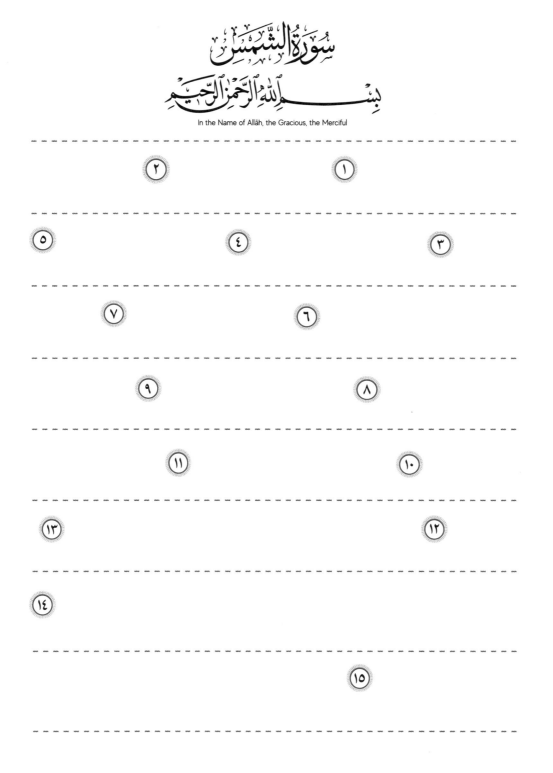

AS-SHAMS
(The Sun)

In the Name of Allāh, the Gracious, the Merciful.

سُورَةُ الشَّمْسِ

بِسْمِ ٱللَّهِ ٱلرَّحْمَٰنِ ٱلرَّحِيمِ

In the Name of Allāh, the Gracious, the Merciful

1. By the sun and its brightness,

2. and the moon as it follows it,

3. and the day as it unveils it,

4. and the night as it conceals it!

5. And by heaven and (the One) Who built it,

6. and the earth and (the One) Who spread it!

7. And by the soul and (the One) Who fashioned it,

8. then with (the knowledge of) right and wrong inspired it!

9. Successful indeed is the one who purifies their soul,

10. and doomed is the one who corrupts it!

11. Thamūd rejected (the truth) out of arrogance,

12. when the most wicked of them was roused (to kill the she-camel).

13. But the messenger of Allāh warned them, "(Do not disturb) Allāh's camel and her (turn to) drink!"

14. Still they defied him and slaughtered her. So their Lord crushed them for their crime, levelling all to the ground.

15. He has no fear of consequences.

وَٱلنَّهَارِ إِذَا ② وَٱلْقَمَرِ إِذَا تَلَىٰهَا ① وَٱلشَّمْسِ وَضُحَىٰهَا

when And the day it follows it when And the moon and its brightness By the sun

جَلَّىٰهَا ⑤ وَٱلَّيْلِ إِذَا يَغْشَىٰهَا ④ وَٱلسَّمَآءِ وَمَا بَنَىٰهَا

constructed it and (he) Who And the heaven it covers it when And the night it displays it

وَٱلْأَرْضِ وَمَا طَحَىٰهَا ⑥ وَنَفْسٍ وَمَا سَوَّىٰهَا ⑦ فَأَلْهَمَهَا

And He inspired it proportioned it and (He) Who And (the) soul spread it and by (He) Who And the earth

فُجُورَهَا وَتَقْوَىٰهَا ⑧ قَدْ أَفْلَحَ مَن زَكَّىٰهَا ⑨ وَقَدْ خَابَ

he fails And indeed purifies it who he succeeds indeed and its righteousness its wickedness (to distinguish,

مَن دَسَّىٰهَا ⑩ كَذَّبَتْ ثَمُودُ بِطَغْوَىٰهَآ ⑪ إِذِ ٱنۢبَعَثَ

sent forth (was) When by their transgression Thamud Denied buries it who

أَشْقَىٰهَا ⑫ فَقَالَ لَهُمْ رَسُولُ ٱللَّهِ نَاقَةَ ٱللَّهِ وَسُقْيَىٰهَا ⑬

and her drink Allāh she-camel (it is the) Allāh Messenger (the) to them But said most wicked of them (a

فَكَذَّبُوهُ فَعَقَرُوهَا فَدَمْدَمَ عَلَيْهِمْ رَبُّهُم بِذَنۢبِهِمْ فَسَوَّىٰهَا ⑭

and levelled them for their sin their Lord them So destroyed and they hamstrung her But they denied h

وَلَا يَخَافُ عُقْبَىٰهَا ⑮

its consequences He fears And no

سُورَةُ الَّيْلِ

بِسْمِ اللّٰهِ الرَّحْمٰنِ الرَّحِيمِ

In the Name of Allāh, the Gracious, the Merciful

AL-LAYL
(The Night)

In the Name of Allāh, the Gracious,
the Merciful.

1. By the night when it covers,

2. and the day when it shines!

3. And by (the One) Who created male and female!

4. Surely the ends you strive for are diverse.

5. As for the one who is charitable, mindful (of Allāh),

6. and (firmly) believes in the finest reward,

7. We will facilitate for them the Way of Ease.

8. And as for the one who is stingy, indifferent (to Allāh),

9. and (staunchly) denies the finest reward,

10. We will facilitate for them the path of hardship.

11. And their wealth will be of no benefit to them when they tumble (into Hell).

12. It is certainly upon Us (alone) to show (the way to) guidance.

13. And surely to Us (alone) belong this life and the next.

14. And so I have warned you of a raging Fire,

15. in which none will burn except the most wretched—

16. who deny and turn away.

17. But the righteous will be spared from it—

18. who donate (some of) their wealth only to purify themselves,

19. not in return for someone's favours,

20. but seeking the pleasure of their Lord, the Most High.

21. They will certainly be pleased.

سُورَةُ الضُّحَى

بِسْمِ ٱللَّهِ ٱلرَّحْمَٰنِ ٱلرَّحِيمِ

In the Name of Allāh, the Gracious, the Merciful

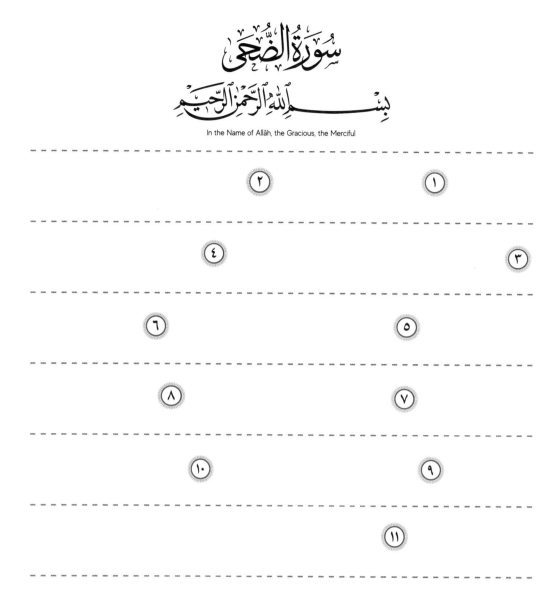

AD-DUHA
(The Morning Sunlight)

In the Name of Allāh, the Gracious,
the Merciful.

سُورَةُ الضُّحَى

بِسْمِ ٱللَّهِ ٱلرَّحْمَٰنِ ٱلرَّحِيمِ

In the Name of Allāh, the Gracious, the Merciful

1. By the morning sunlight,

2. and the night when it falls still!

وَٱلضُّحَىٰ ﴿١﴾ وَٱلَّيْلِ إِذَا سَجَىٰ ﴿٢﴾ مَا وَدَّعَكَ رَبُّكَ وَمَا قَلَىٰ

He is displeased	and not	your Lord	has forsaken you	Not	it covers with darkness	when	And the night	By the morning brightn

3. Your Lord (O Prophet) has not abandoned you, nor has He become hateful (of you).

﴿٣﴾ وَلَلْءَاخِرَةُ خَيْرٌ لَّكَ مِنَ ٱلْأُولَىٰ ﴿٤﴾ وَلَسَوْفَ يُعْطِيكَ

will give you	And soon		the first	than	for you	better (is)	And surely the Hereafter

4. And the next life is certainly far better for you than this one.

5. And (surely) your Lord will give so much to you that you will be pleased.

رَبُّكَ فَتَرْضَىٰ ﴿٥﴾ أَلَمْ يَجِدْكَ يَتِيمًا فَـَٔاوَىٰ ﴿٦﴾ وَوَجَدَكَ

And He found you		and give shelter	an orphan	He find you	Did not	then you will be satisfied	your Lo

6. Did He not find you as an orphan then shelter you?

ضَآلًّا فَهَدَىٰ ﴿٧﴾ وَوَجَدَكَ عَآئِلًا فَأَغْنَىٰ ﴿٨﴾ فَأَمَّا ٱلْيَتِيمَ

the orphan	So as for	so He made self-sufficient	in need	And He found you	so He guided	lost

7. Did He not find you unguided then guide you?

8. And did He not find you needy then satisfy your needs?

فَلَا تَقْهَرْ ﴿٩﴾ وَأَمَّا ٱلسَّآئِلَ فَلَا تَنْهَرْ ﴿١٠﴾ وَأَمَّا بِنِعْمَةِ

Favour (the)	But as for		repel	then (do)not	one who asks	As as for		oppress	then (do)

9. So do not oppress the orphan,

10. nor repulse the beggar.

رَبِّكَ فَحَدِّثْ ﴿١١﴾

narrate	your Lord (

11. And proclaim the blessings of your Lord.

سُورَةُ الشَّرْحِ

بِسْمِ ٱللَّهِ ٱلرَّحْمَٰنِ ٱلرَّحِيمِ

In the Name of Allāh, the Gracious, the Merciful

② ①

④ ③

⑥ ⑤

⑧ ⑦

سُورَةُ التِّينِ

بِسْمِ ٱللَّهِ ٱلرَّحْمَٰنِ ٱلرَّحِيمِ

In the Name of Allāh, the Gracious, the Merciful

③ ② ①

④

⑤

⑦ ⑥

⑧

AL-SHARH
(Uplifting the Heart)

In the Name of Allāh, the Gracious, the Merciful.

In the Name of Allāh, the Gracious, the Merciful

1. Have We not uplifted your heart for you (O Prophet),

2. relieved you of the burden

3. which weighed so heavily on your back,

4. and elevated your renown for you?

5. So, surely with hardship comes ease.

6. Surely with (that) hardship comes (more) ease.

7. So once you have fulfilled (your duty), strive (in devotion),

8. turning to your Lord (alone) with hope.

أَلَمْ نَشْرَحْ لَكَ صَدْرَكَ ۝ وَوَضَعْنَا عَنكَ وِزْرَكَ ۝ ٱلَّذِيٓ

Which · your Burden · from you · And We removed · your breast · for you · We expanded · Have

نقَضَ ظَهْرَكَ ۝ وَرَفَعْنَا لَكَ ذِكْرَكَ ۝ فَإِنَّ مَعَ ٱلْعُسْرِ

the hardship · with · So indeed · your reputation · for you · And We raised high · your back · weighed up

سْرًا ۝ إِنَّ مَعَ ٱلْعُسْرِ يُسْرًا ۝ فَإِذَا فَرَغْتَ فَٱنصَبْ

the labour hard · you have finished · So when · ease (is) · the hardship · with · Indeed · ease

وَإِلَىٰ رَبِّكَ فَٱرْغَب ۝

turn your attention · your Lord · And to

AL-TIN
(The Fig)

In the Name of Allāh, the Gracious, the Merciful.

In the Name of Allāh, the Gracious, the Merciful

1. By the fig and the olive (of Jerusalem),

2. and Mount Sinai,

3. and this secure city (of Mecca)!

4. Indeed, We created humans in the best form.

5. But We will reduce them to the lowest of the low (in Hell),

6. except those who believe and do good—they will have a never-ending reward

7. Now, what makes you deny the (final) Judgement?

8. Is Allāh not the most just of all judges?

وَٱلتِّينِ وَٱلزَّيْتُونِ ۝ وَطُورِ سِينِينَ ۝ وَهَٰذَا ٱلْبَلَدِ ٱلْأَمِينِ ۝

secure (the) · city (the) · And this · Sinai · And (the) Mount · and the olive · By the fi

نْدَ خَلَقْنَا ٱلْإِنسَٰنَ فِىٓ أَحْسَنِ تَقْوِيمٍ ۝ ثُمَّ رَدَدْنَٰهُ أَسْفَلَ

lowest (to the) · We returned him · Then · mould · best (the) · in · man · We created · Ind

سَٰفِلِينَ ۝ إِلَّا ٱلَّذِينَ ءَامَنُوا۟ وَعَمِلُوا۟ ٱلصَّٰلِحَٰتِ فَلَهُمْ أَجْرٌ

reward (is a) · then for them · righteous deeds · and do · believe · those who · Except · low (of the

يْرُ مَمْنُونٍ ۝ فَمَا يُكَذِّبُكَ بَعْدُ بِٱلدِّينِ ۝ أَلَيْسَ ٱللَّهُ

Allāh · Is not · the judgement · after (this) · causes you deny · Then what · ending · never

ۡحْكَمِ ٱلْحَٰكِمِينَ ۝

the Judges (of) · Most just (

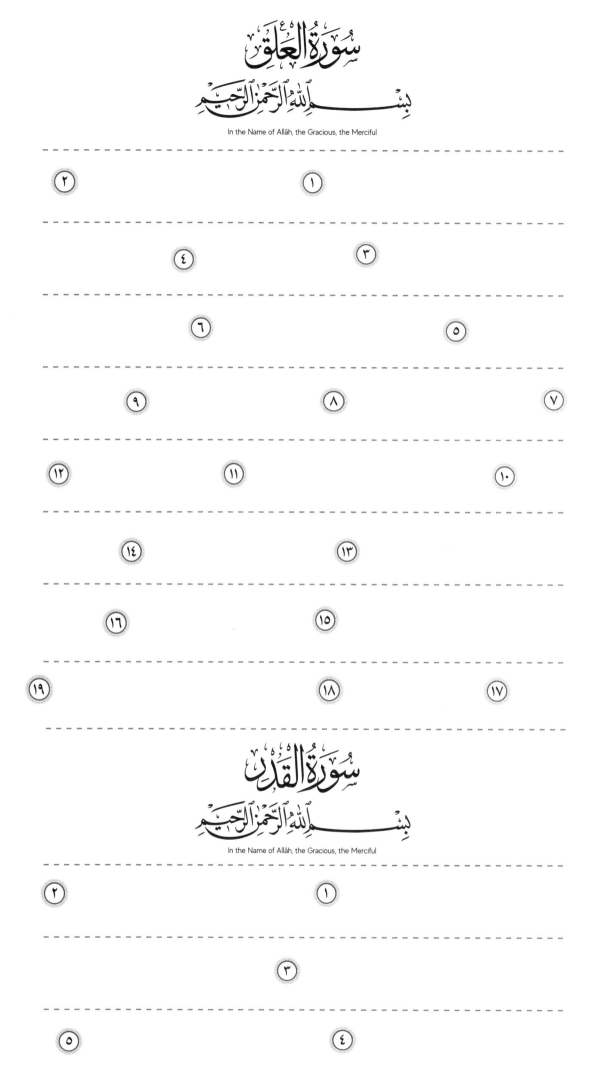

سُورَةُ الْعَلَق

بِسْمِ اللهِ الرَّحْمَنِ الرَّحِيمِ

In the Name of Allāh, the Gracious, the Merciful

٢ ١

٤ ٣

٦ ٥

٩ ٨ ٧

١٢ ١١ ١٠

١٤ ١٣

١٦ ١٥

١٩ ١٨ ١٧

سُورَةُ الْقَدْر

بِسْمِ اللهِ الرَّحْمَنِ الرَّحِيمِ

In the Name of Allāh, the Gracious, the Merciful

٢ ١

٣

٥ ٤

<div dir="rtl">

الجُزْءُ الثَّلَاثُونَ

سُورَةُ العَلَقِ

بِسْمِ ٱللَّهِ ٱلرَّحْمَٰنِ ٱلرَّحِيمِ

</div>

In the Name of Allāh, the Gracious, the Merciful

AL-'ALAQ
(The Clinging Clot (of blood))

In the Name of Allāh, the Gracious, the Merciful.

1. Read, (O Prophet), in the Name of your Lord Who created–

2. created humans from a clinging clot.

3. Read! And your Lord is the Most Generous,

4. Who taught by the pen–

5. taught humanity what they knew not.

6. Most certainly, one exceeds all bounds

7. once they think they are self-sufficient.

8. (But) surely to your Lord is the return (of all).

9. Have you seen the man who prevents

10. a servant (of Ours) from praying?

11. What if this (servant) is (rightly) guided,

12. or encourages righteousness?

13. What if that (man) persists in denial and turns away?

14. Does he not know that Allāh sees (all)?

15. But no! If he does not desist, We will certainly drag him by the forelock–

16. a lying, sinful forelock.

17. So let him call his associates.

18. We will call the wardens of Hell.

19. Again, no! Never obey him (O Prophet)! Rather, (continue to) prostrate and draw near (to Allāh).

<div dir="rtl">

ٱقْرَأْ بِٱسْمِ رَبِّكَ ٱلَّذِى خَلَقَ ١ خَلَقَ ٱلْإِنسَٰنَ مِنْ عَلَقٍ ٢

| a clinging substance | from | man | He created | | created | the One who | your Lord | (of) | in (the) Name | Read |

ٱقْرَأْ وَرَبُّكَ ٱلْأَكْرَمُ ٣ ٱلَّذِى عَلَّمَ بِٱلْقَلَمِ ٤ عَلَّمَ ٱلْإِنسَٰنَ

| man | Taught | | by the pen | taught | The One who | | the Most Generous (is) | and your Lord | Read |

مَا لَمْ يَعْلَمْ ٥ كَلَّا إِنَّ ٱلْإِنسَٰنَ لَيَطْغَىٰٓ ٦ أَن رَّءَاهُ ٱسْتَغْنَىٰٓ

| self-sufficient | he sees himself | That | surely transgresses | man | Indeed | Nay | he knew | not |

٧ إِنَّ إِلَىٰ رَبِّكَ ٱلرُّجْعَىٰٓ ٨ أَرَءَيْتَ ٱلَّذِى يَنْهَىٰ ٩ عَبْدًا إِذَا

| when | A slave | forbids | the one who | Have you seen | the return (is) | your Lord | to | Indeed |

صَلَّىٰٓ ١٠ أَرَءَيْتَ إِن كَانَ عَلَى ٱلْهُدَىٰٓ ١١ أَوْ أَمَرَ بِٱلتَّقْوَىٰٓ ١٢

| righteousness (of the) | he enjoins | Or | guidance (the) | upon | he is | when | Have you seen | he pra |

أَرَءَيْتَ إِن كَذَّبَ وَتَوَلَّىٰٓ ١٣ أَلَمْ يَعْلَم بِأَنَّ ٱللَّهَ يَرَىٰ ١٤ كَلَّا لَئِن

| if | Nay | sees | Allāh | that | he know | Does not | and turns away | he denies | if | Have you |

لَّمْ يَنتَهِ لَنَسْفَعًۢا بِٱلنَّاصِيَةِ ١٥ نَاصِيَةٍ كَٰذِبَةٍ خَاطِئَةٍ ١٦ فَلْيَدْعُ

| Then let him call | sinful | lying | by the forelock | by the forelock | surely We will drag him | he desists |

نَادِيَهُۥ ١٧ سَنَدْعُ ٱلزَّبَانِيَةَ ١٨ كَلَّا لَا تُطِعْهُ وَٱسْجُدْ وَٱقْتَرِب ۩ ١٩

| and draw near (to Allāh) | but prostrate | obey him | no (Do) | Nay | the Angels of Hell | We will call | his associa |

سُورَةُ القَدْرِ

بِسْمِ ٱللَّهِ ٱلرَّحْمَٰنِ ٱلرَّحِيمِ

</div>

In the Name of Allāh, the Gracious, the Merciful

AL-QADR
(The Night of Glory)

In the Name of Allāh, the Gracious, the Merciful.

1. Indeed, (It is) We Who sent this (Qur'ān) down on the Night of Glory.

2. And what will make you realize what the Night of Glory is?

3. The Night of Glory is better than a thousand months.

4. That night the angels and the (holy) spirit descend, by the permission of their Lord, for every (decreed) matter.

5. It is all peace until the break of dawn.

<div dir="rtl">

إِنَّآ أَنزَلْنَٰهُ فِى لَيْلَةِ ٱلْقَدْرِ ١ وَمَآ أَدْرَىٰكَ مَا لَيْلَةُ ٱلْقَدْرِ ٢

| Power (is)(of) | Night (the) | what | can make you know | And what | Power (of) | Night (the) | in | revealed it | Indeed |

لَيْلَةُ ٱلْقَدْرِ خَيْرٌ مِّنْ أَلْفِ شَهْرٍ ٣ تَنَزَّلُ ٱلْمَلَٰٓئِكَةُ وَٱلرُّوحُ فِيهَا

| therein | and the Spirit | the Angels | Descend | month (s) | a thousand | than | better (is) | Power (of) | Night |

بِإِذْنِ رَبِّهِم مِّن كُلِّ أَمْرٍ ٤ سَلَٰمٌ هِىَ حَتَّىٰ مَطْلَعِ ٱلْفَجْرِ ٥

| the dawn (of) | emergence (the) | until | it (is) | Peace | affair | every | for | their lord (of) | by (the) pe |

</div>

سُورَةُ الْبَيِّنَةِ

بِسْمِ اللّٰهِ الرَّحْمٰنِ الرَّحِيمِ

In the Name of Allāh, the Gracious, the Merciful

- -

- -

①

- -

③ ②

- -

④

- -

- -

⑤

- -

⑥

- -

⑦

- -

- -

⑧

- -

AL-BAYYINAH
(The Clear Proof)

In the Name of Allāh, the Gracious, the Merciful.

سُورَةُ البَيِّنَة

بِسْمِ اللَّهِ الرَّحْمَٰنِ الرَّحِيمِ

In the Name of Allāh, the Gracious, the Merciful

1. The disbelievers from the People of the Book and the polytheists were not going to desist (from disbelief) until the clear proof came to them:

لَمْ يَكُنِ ٱلَّذِينَ كَفَرُوا۟ مِنْ أَهْلِ ٱلْكِتَٰبِ وَٱلْمُشْرِكِينَ مُنفَكِّينَ

to be abandoned	and the polytheists	of the book	People (the)	from	disbelieved	those who	were	No

2. a messenger from Allāh, reciting scrolls of (utmost) purity,

حَتَّىٰ تَأْتِيَهُمُ ٱلْبَيِّنَةُ ١ رَسُولٌ مِّنَ ٱللَّهِ يَتْلُوا۟ صُحُفًا مُّطَهَّرَةً

purified	pages	reciting	Allāh	from	A messenger	the clear evidence	comes to them (there)	until

3. containing upright commandments.

٢ فِيهَا كُتُبٌ قَيِّمَةٌ ٣ وَمَا تَفَرَّقَ ٱلَّذِينَ أُوتُوا۟ ٱلْكِتَٰبَ إِلَّا

until	the book	were	those who	became divided	And not	correct	writings (are)	Wherein

4. It was not until this clear proof came to the People of the Book that they became divided (about his prophethood)–

مِنۢ بَعْدِ مَا جَآءَتْهُمُ ٱلْبَيِّنَةُ ٤ وَمَآ أُمِرُوٓا۟ إِلَّا لِيَعْبُدُوا۟ ٱللَّهَ

Allāh	to worship	except	they were commanded	And not	the clear evidence (of) came (to) them	what	after	from

5. even though they were only commanded to worship Allāh (alone) with sincere devotion to Him in all uprightness, establish prayer, and pay alms-tax. That is the upright Way.

مُخْلِصِينَ لَهُ ٱلدِّينَ حُنَفَآءَ وَيُقِيمُوا۟ ٱلصَّلَوٰةَ وَيُؤْتُوا۟ ٱلزَّكَوٰةَ

the zakah	and to give	the prayer	and to establish	upright	the religion (in)	to Him	sincere (being

وَذَٰلِكَ دِينُ ٱلْقَيِّمَةِ ٥ إِنَّ ٱلَّذِينَ كَفَرُوا۟ مِنْ أَهْلِ ٱلْكِتَٰبِ

the Book (of)	People (the)	from	disbelieve	those who	Indeed	the correct	religion (is the)	And that

6. Indeed, those who disbelieve from the People of the Book and the polytheists will be in the Fire of Hell, to stay there forever. They are the worst of (all) beings.

وَٱلْمُشْرِكِينَ فِى نَارِ جَهَنَّمَ خَٰلِدِينَ فِيهَآ أُو۟لَٰٓئِكَ هُمْ شَرُّ

worst (are the)	they	those	therein	abiding eternally	Hell (of)	Fire (the)	in (will be)	and the polytheists

7. Indeed, those who believe and do good–they are the best of (all) beings.

ٱلْبَرِيَّةِ ٦ إِنَّ ٱلَّذِينَ ءَامَنُوا۟ وَعَمِلُوا۟ ٱلصَّٰلِحَٰتِ أُو۟لَٰٓئِكَ هُمْ

they	those	righteous deeds	and do	believe	those who	Indeed	the creatures

8. Their reward with their Lord will be Gardens of Eternity, under which rivers flow, to stay there for ever and ever. Allāh is pleased with them and they are pleased with Him. This is (only) for those in awe of their Lord.

خَيْرُ ٱلْبَرِيَّةِ ٧ جَزَآؤُهُمْ عِندَ رَبِّهِمْ جَنَّٰتُ عَدْنٍ تَجْرِى

flow	Eternity (of)	Gardens	their Lord	with (is)	Their reward	the creatures (of)	best (are th

مِن تَحْتِهَا ٱلْأَنْهَٰرُ خَٰلِدِينَ فِيهَآ أَبَدًا رَّضِىَ ٱللَّهُ عَنْهُمْ

with them	Allāh	please (will be)	forever	therein	will abide	the rivers	underneath them	from

وَرَضُوا۟ عَنْهُ ذَٰلِكَ لِمَنْ خَشِىَ رَبَّهُۥ ٨

his Lord	feared	for whoever (is)	That	with Him	and they (will be) pleas

سُورَةُ الزَّلْزَلَةِ

بِسْمِ اللَّهِ الرَّحْمَٰنِ الرَّحِيمِ

In the Name of Allāh, the Gracious, the Merciful

① ② ③ ④ ⑤ ⑥ ⑦ ⑧

سُورَةُ الْعَادِيَاتِ

بِسْمِ اللَّهِ الرَّحْمَٰنِ الرَّحِيمِ

In the Name of Allāh, the Gracious, the Merciful

① ② ③ ④ ⑤ ⑥ ⑦ ⑧ ⑨ ⑩ ⑪

AZ-ZALZALAH
(The (Ultimate) Earthquake)

سُورَةُ الزَّلْزَلَةِ

بِسْمِ اللَّهِ الرَّحْمَٰنِ الرَّحِيمِ

In the Name of Allāh, the Gracious, the Merciful

In the Name of Allāh, the Gracious, the Merciful.

1. When the earth is shaken (in) its ultimate quaking,

2. and when the earth throws out (all) its contents,

3. and humanity cries, "What is wrong with it?"–

إِذَا زُلْزِلَتِ ٱلْأَرْضُ زِلْزَالَهَا ﴿١﴾ وَأَخْرَجَتِ ٱلْأَرْضُ

the earth And brings forth its earthquake (with) the earth is shaken When

4. on that Day the earth will recount everything,

5. having been inspired by your Lord (to do so).

ثِقَالَهَا ﴿٢﴾ وَقَالَ ٱلْإِنسَٰنُ مَا لَهَا ﴿٣﴾ يَوْمَئِذٍ تُحَدِّثُ

it will report That Day with it (is) what man And says it burdens

6. On that Day people will proceed in separate groups to be shown (the consequences of) their deeds.

أَخْبَارَهَا ﴿٤﴾ بِأَنَّ رَبَّكَ أَوْحَىٰ لَهَا ﴿٥﴾ يَوْمَئِذٍ يَصْدُرُ

will proceed That Day it (to) inspired your Lord Because its news

7. So whoever does an atom's weight of good will see it.

ٱلنَّاسُ أَشْتَاتًا لِّيُرَوْا۟ أَعْمَٰلَهُمْ ﴿٦﴾ فَمَن يَعْمَلْ مِثْقَالَ ذَرَّةٍ

an atom (of) weight (equal to the) does So whoever their deeds to be shown scattered groups (in) the mankind

8. And whoever does an atom's weight of evil will see it.

خَيْرًا يَرَهُۥ ﴿٧﴾ وَمَن يَعْمَلْ مِثْقَالَ ذَرَّةٍ شَرًّا يَرَهُۥ ﴿٨﴾

will see it evil an atom (of) weight (equal to the) does And whoever will see it good

AL-ʿĀDIYĀT
(The Galloping 'Horses')

سُورَةُ ٱلْعَادِيَاتِ

بِسْمِ اللَّهِ الرَّحْمَٰنِ الرَّحِيمِ

In the Name of Allāh, the Gracious, the Merciful

In the Name of Allāh, the Gracious, the Merciful.

1. By the galloping, panting horses,

2. striking sparks of fire (with their hoofs),

3. launching raids at dawn,

وَٱلْعَٰدِيَٰتِ ضَبْحًا ﴿١﴾ فَٱلْمُورِيَٰتِ قَدْحًا ﴿٢﴾ فَٱلْمُغِيرَٰتِ صُبْحًا ﴿٣﴾

dawn (at) And the chargers striking And the producers of sparks panting By the racers

4. stirring up (clouds of) dust,

5. and penetrating into the heart of enemy lines!

فَأَثَرْنَ بِهِۦ نَقْعًا ﴿٤﴾ فَوَسَطْنَ بِهِۦ جَمْعًا ﴿٥﴾ إِنَّ ٱلْإِنسَٰنَ

mankind Indeed collectively thereby Then penetrate (in the)center dust thereby Then raise

6. Surely humankind is ungrateful to their Lord–

7. and they certainly attest to this–

لِرَبِّهِۦ لَكَنُودٌ ﴿٦﴾ وَإِنَّهُۥ عَلَىٰ ذَٰلِكَ لَشَهِيدٌ ﴿٧﴾ وَإِنَّهُۥ لِحُبِّ

in (the)love And indeed he surely (is)a witness that on And indeed, he surely ungrateful (is) to his Lord

8. and they are truly extreme in their love of (worldly) gains.

9. Do they not know that when the contents of the graves will be spilled out,

ٱلْخَيْرِ لَشَدِيدٌ ﴿٨﴾ أَفَلَا يَعْلَمُ إِذَا بُعْثِرَ مَا فِى ٱلْقُبُورِ ﴿٩﴾

the graves in (is) what will be scattered when he know But does not surely intense (is) wealth (of)

10. and the secrets of the hearts will be laid bare–

11. surely their Lord is All-Aware of them on that Day.

وَحُصِّلَ مَا فِى ٱلصُّدُورِ ﴿١٠﴾ إِنَّ رَبَّهُم بِهِمْ يَوْمَئِذٍ لَّخَبِيرٌ

surely All-Aware (is) that Day about them their Lord Indeed the breasts in (is) what And is made appa

سُورَةُ الْقَارِعَةِ

بِسْمِ اللّٰهِ الرَّحْمٰنِ الرَّحِيمِ

In the Name of Allāh, the Gracious, the Merciful

- -

③ ② ①

- -

④

- -

⑥ ⑤

- -

⑧ ⑦

- -

⑩ ⑨

- -

⑪

سُورَةُ التَّكَاثُرِ

بِسْمِ اللّٰهِ الرَّحْمٰنِ الرَّحِيمِ

In the Name of Allāh, the Gracious, the Merciful

- -

② ①

- -

④ ③

- -

⑥ ⑤

- -

⑧ ⑦

- -

AL-QĀRI'AH
(The Striking Disaster)

In the Name of Allāh, the Gracious, the Merciful.

In the Name of Allāh, the Gracious, the Merciful

1. The Striking Disaster!

2. What is the Striking Disaster?

3. And what will make you realize what the Striking Disaster is?

ٱلْقَارِعَةُ ①	مَا ٱلْقَارِعَةُ ②	وَمَآ أَدْرَىٰكَ مَا ٱلْقَارِعَةُ ③
The striking Disaster!	What (is) the Striking Calamity	And what will make you know what (is) the Striking Calamity

4. (It is) the Day people will be like scattered moths,

5. and the mountains will be like carded wool.

يَوْمَ يَكُونُ ٱلنَّاسُ كَٱلْفَرَاشِ ٱلْمَبْثُوثِ ④ وَتَكُونُ
(The) Day will be the mankind like moths scattered And will be

6. So as for those whose scale is heavy (with good deeds),

7. they will be in a life of bliss.

ٱلْجِبَالُ كَٱلْعِهْنِ ٱلْمَنفُوشِ ⑤ فَأَمَّا مَن ثَقُلَتْ مَوَٰزِينُهُۥ ⑥
the mountains like wool fluffed up Then as for whose (him) heavy (are) his scales

8. And as for those whose scale is light,

9. their home will be the abyss.

فَهُوَ فِي عِيشَةٍ رَّاضِيَةٍ ⑦ وَأَمَّا مَنْ خَفَّتْ مَوَٰزِينُهُۥ ⑧
Then he in (will be) a life pleasant But as for whose (him) light (are) his scales

10. And what will make you realize what that is?

فَأُمُّهُۥ هَاوِيَةٌ ⑨ وَمَآ أَدْرَىٰكَ مَا هِيَهْ ⑩
His abode Pit (will be there) And what will make you know what it is

11. (It is) a scorching Fire.

نَارٌ حَامِيَةٌۢ ⑪
A Fire intensely hot

AT-TAKĀTHUR
(Competition for More (Gains))

In the Name of Allāh, the Gracious, the Merciful.

In the Name of Allāh, the Gracious, the Merciful

1. Competition for more (gains) diverts you (from Allāh),

2. until you end up in (your) graves.

3. But no! You will soon come to know.

أَلْهَىٰكُمُ ٱلتَّكَاثُرُ ① حَتَّىٰ زُرْتُمُ ٱلْمَقَابِرَ ② كَلَّا سَوْفَ
Diverts you the competition to increase Until you visit the graves Nay soon

4. Again, no! You will soon come to know.

تَعْلَمُونَ ③ ثُمَّ كَلَّا سَوْفَ تَعْلَمُونَ ④ كَلَّا لَوْ تَعْلَمُونَ
you will know Then nay soon you will know Nay if you know

5. Indeed, if you were to know (your fate) with certainty, (you would have acted differently).

6. (But) you will surely see the Hellfire.

عِلْمَ ٱلْيَقِينِ ⑤ لَتَرَوُنَّ ٱلْجَحِيمَ ⑥ ثُمَّ لَتَرَوُنَّهَا عَيْنَ ٱلْيَقِينِ
a knowledge (with) certainty (of) Surely you will see the Hell-fire Then Surely you will see it about the pleasures

7. Again, you will surely see it with the eye of certainty.

8. Then, on that Day, you will definitely be questioned about (your worldly) pleasures.

ثُمَّ لَتُسْـَٔلُنَّ يَوْمَئِذٍ عَنِ ٱلنَّعِيمِ ⑧
Then surely you will be asked that Day about the pleasures

سُوْرَةُ الْعَصْرِ

بِسْمِ اللهِ الرَّحْمٰنِ الرَّحِيْمِ
In the Name of Allāh, the Gracious, the Merciful

- -

② ①

- -

③

- -

سُوْرَةُ الْهُمَزَةِ

بِسْمِ اللهِ الرَّحْمٰنِ الرَّحِيْمِ
In the Name of Allāh, the Gracious, the Merciful

- -

② ①

- -

④ ③

- -

⑥ ⑤

- -

⑨ ⑧ ⑦

- -

سُوْرَةُ الْفِيْلِ

بِسْمِ اللهِ الرَّحْمٰنِ الرَّحِيْمِ
In the Name of Allāh, the Gracious, the Merciful

- -

①

- -

③ ②

- -

⑤ ④

AL-AṢR
(The (Passage of) Time)

In the Name of Allāh, the Gracious, the Merciful.

1. By the (passage of) time!

2. Surely humanity is in (grave) loss,

3. except those who have faith, do good, and urge each other to the truth, and urge each other to perseverance.

سُورَةُ الْعَصْرِ

بِسْمِ اللَّهِ الرَّحْمَٰنِ الرَّحِيمِ

In the Name of Allāh, the Gracious, the Merciful

إِلَّا ٱلَّذِينَ ءَامَنُوا ٢ إِنَّ ٱلْإِنسَٰنَ لَفِي خُسْرٍ ١ وَٱلْعَصْرِ

believe those who Except | loss surely, in (is) mankind Indeed | By the time

وَتَوَاصَوْا بِٱلصَّبْرِ ٣ وَعَمِلُوا ٱلصَّٰلِحَٰتِ وَتَوَاصَوْا بِٱلْحَقِّ

to (the) patience and enjoin (each other) | to the truth and enjoin (each other) righteous deeds and do

AL-HUMAZAH
(The Backbiters)

In the Name of Allāh, the Gracious, the Merciful.

1. Woe to every backbiter, slanderer,

2. who amasses wealth (greedily) and counts it (repeatedly),

3. thinking that their wealth will make them immortal!

4. Not at all! Such a person will certainly be tossed into the Crusher.

5. And what will make you realize what the Crusher is?

6. (It is) Allāh's kindled Fire,

7. which rages over the hearts.

8. It will be sealed over them,

9. (tightly secured) with long braces.

سُورَةُ الْهُمَزَةِ

بِسْمِ اللَّهِ الرَّحْمَٰنِ الرَّحِيمِ

In the Name of Allāh, the Gracious, the Merciful

ٱلَّذِي جَمَعَ مَالًا وَعَدَّدَهُ ٢ وَيْلٌ لِّكُلِّ هُمَزَةٍ لُّمَزَةٍ ١

and counts it wealth collects The one who | backbiter slanderer to every Woe

كَلَّا لَيُنبَذَنَّ فِي ٱلْحُطَمَةِ ٤ يَحْسَبُ أَنَّ مَالَهُ أَخْلَدَهُ ٣

the Crusher in Surely he will be thrown Nay | will make him immortal his wealth that Thinking

ٱلَّتِي تَطَّلِعُ ٦ نَارُ ٱللَّهِ ٱلْمُوقَدَةُ ٥ وَمَآ أَدْرَىٰكَ مَا ٱلْحُطَمَةُ

mounts up Which | kindled Allāh A fire | the Crusher (is) what will make you know And what

عَلَى ٱلْأَفْئِدَةِ ٧ إِنَّهَا عَلَيْهِم مُّؤْصَدَةٌ ٨ فِي عَمَدٍ مُّمَدَّدَةٍ ٩

extended columns In | closed over upon them (will be) Indeed, it | the hearts to

AL-FĪL
(The Elephant)

In the Name of Allāh, the Gracious, the Merciful.

1. Have you not seen (O Prophet) how your Lord dealt with the Army of the Elephant?

2. Did He not frustrate their scheme?

3. For He sent against them flocks of birds,

4. that pelted them with stones of baked clay,

5. leaving them like chewed up straw.

سُورَةُ الْفِيلِ

بِسْمِ اللَّهِ الرَّحْمَٰنِ الرَّحِيمِ

In the Name of Allāh, the Gracious, the Merciful

أَلَمْ يَجْعَلْ ١ أَلَمْ تَرَ كَيْفَ فَعَلَ رَبُّكَ بِأَصْحَٰبِ ٱلْفِيلِ

He make Did not | Elephant (of the) with (the) Lord your Lord dealt how you seen Have no[t]

وَأَرْسَلَ عَلَيْهِمْ طَيْرًا أَبَابِيلَ ٣ كَيْدَهُمْ فِي تَضْلِيلٍ ٢

flocks (in) birds against them And he sent | astray go their plan

فَجَعَلَهُمْ كَعَصْفٍ مَّأْكُولٍ ٥ تَرْمِيهِم بِحِجَارَةٍ مِّن سِجِّيلٍ ٤

eaten up like straw Then he made them | baked clay of with stones Striking them

سُورَةُ قُرَيْشٍ

بِسْمِ اللهِ الرَّحْمَنِ الرَّحِيمِ

In the Name of Allāh, the Gracious, the Merciful

① ------------------------------

------------------------------------- ③ ----------- ② --------

----------------- ④ --------------------------------

سُورَةُ الْمَاعُونِ

بِسْمِ اللهِ الرَّحْمَنِ الرَّحِيمِ

In the Name of Allāh, the Gracious, the Merciful

① ------------------------------

-------------- ③ ------------------ ② --------

-------------------- ④ ------------

-------- ⑦ ---------------- ⑥ ---------------- ⑤ --------

سُورَةُ الْكَوْثَرِ

بِسْمِ اللهِ الرَّحْمَنِ الرَّحِيمِ

In the Name of Allāh, the Gracious, the Merciful

-------- ② ---------------- ① --------

-------------------- ③ ------------

QURAYSH
(The People of Quraysh)

In the Name of Allāh, the Gracious, the Merciful.

1. (At least) for (the favour of) making Quraysh habitually secure—

2. secure in their trading caravan (to Yemen) in the winter and (Syria) in the summer—

3. let them worship the Lord of this Sacred House,

4. Who has fed them against hunger and made them secure against fear.

AL-MĀ'ŪN
(Simplest Aid)

In the Name of Allāh, the Gracious, the Merciful.

1. Have you seen the one who denies the (final) Judgement?

2. That is the one who repulses the orphan,

3. and does not encourage the feeding of the poor.

4. So woe to those (hypocrites) who pray

5. yet are unmindful of their prayers;

6. those who (only) show off,

7. and refuse to give (even the simplest) aid.

AL-KAWTHAR
(Abundant Goodness)

In the Name of Allāh, the Gracious, the Merciful.

1. Indeed, We have granted you (O Prophet) abundant goodness.

2. So pray and sacrifice to your Lord (alone).

3. Only the one who hates you is truly cut off (from any goodness).

سُورَةُ الْكَافِرُونَ

بِسْمِ اللهِ الرَّحْمَنِ الرَّحِيمِ

In the Name of Allāh, the Gracious, the Merciful

- -

٢ ١

- -

٤ ٣

- -

٦ ٥

- -

سُورَةُ النَّصْرِ

بِسْمِ اللهِ الرَّحْمَنِ الرَّحِيمِ

In the Name of Allāh, the Gracious, the Merciful

- -

٢ ١

- -

٣

- -

٤

- -

سُورَةُ الْمَسَدِ

بِسْمِ اللهِ الرَّحْمَنِ الرَّحِيمِ

In the Name of Allāh, the Gracious, the Merciful

- -

١

- -

٣ ٢

- -

٥ ٤

AL-KĀFIRŪN
(The Disbelievers)

سُورَةُ الْكَافِرُونَ

بِسْمِ اللَّهِ الرَّحْمَٰنِ الرَّحِيمِ

In the Name of Allāh, the Gracious, the Merciful

In the Name of Allāh, the Gracious, the Merciful.

1. Say, (O Prophet) "O you disbelievers!

2. I do not worship what you worship,

3. nor do you worship what I worship.

4. I will never worship what you worship,

5. nor will you ever worship what I worship.

6. You have your way, and I have my Way."

AN-NAṢR
(The (Ultimate) Help)

سُورَةُ النَّصْرِ

بِسْمِ اللَّهِ الرَّحْمَٰنِ الرَّحِيمِ

In the Name of Allāh, the Gracious, the Merciful

In the Name of Allāh, the Gracious, the Merciful.

1. When Allāh's (ultimate) help comes and the victory over Mecca is achieved

2. and you (O Prophet) see the people embracing Allāh's Way in crowds,

3. then glorify the praises of your Lord and seek His forgiveness, for certainly He is ever Accepting of Repentance.

AL-MASAD
(The Palm Fibre Rope)

سُورَةُ الْمَسَدِ

بِسْمِ اللَّهِ الرَّحْمَٰنِ الرَّحِيمِ

In the Name of Allāh, the Gracious, the Merciful

In the Name of Allāh, the Gracious, the Merciful.

1. May the hands of Abu Lahab perish, and he(himself) perish!

2. Neither his wealth nor(worldly) gains will benefit him.

3. He will burn in a flaming Fire,

4. and (so will) his wife, the carrier of (thorny) kindling,

5. around her neck will be a rope of palm-fibre.

سُورَةُ الْإِخْلَاصِ

بِسْمِ اللّٰهِ الرَّحْمٰنِ الرَّحِيمِ

In the Name of Allāh, the Gracious, the Merciful

٢ ١

٤ ٣

سُورَةُ الْفَلَقِ

بِسْمِ اللّٰهِ الرَّحْمٰنِ الرَّحِيمِ

In the Name of Allāh, the Gracious, the Merciful

٢ ١

٣

٥ ٤

سُورَةُ النَّاسِ

بِسْمِ اللّٰهِ الرَّحْمٰنِ الرَّحِيمِ

In the Name of Allāh, the Gracious, the Merciful

٢ ١

٤ ٣

٥

٦

AL-IKHLĀṢ
(Purity of Faith)

In the Name of Allāh, the Gracious, the Merciful.

1. Say, (O Prophet), "He is Allāh–One (and Indivisible);

2. Allāh–the Sustainer (needed by all).

3. He has never had offspring, nor was He born.

4. And there is none comparable to Him."

AL-FALAQ
(The Daybreak)

In the Name of Allāh, the Gracious, the Merciful.

1. Say, (O Prophet), "I seek refuge in the Lord of the daybreak

2. from the evil of whatever He has created,

3. and from the evil of the night when it grows dark,

4. and from the evil of those (witches casting spells by)blowing onto knots,

5. and from the evil of an envier when they envy."

AN-NĀS
(Humankind)

In the Name of Allāh, the Gracious, the Merciful.

1. Say, (O Prophet) "I seek refuge in the Lord of humankind,

2. the Master of humankind,

3. the God of humankind,

4. from the evil of the lurking whisperer–

5. who whispers into the hearts of humankind–

6. from among jinn and humankind."

BIBLIOGRAPHY

Qur'ān source:

o Dr. Mustafa Khattab, The Clear Qur'ān: A Thematic English Translation of the Message of the Final Revelation, Book of Signs Foundation, 2016

Aḥādīth sources (sayings of the Prophet ﷺ):

o Imām Al-Ḥākim, Al-Mustadrak, Dar Al-Kotob Al-ilmiyah Beirut, 1990, First Edition, verified by Muṣṭafā Abdul Qādir 'Aṭā

Scholarly/Other sources:

o Imām Ibn Al-Qayyim Al-Jawziyyah, Miftā Dār As-Sa'ādah wa Manshūr Wilāyah Al-'Ilm wa Al-Irādah, Sulaiman Bin Abdulaziz Al Rajhi Charitable Foundation, 1432, First Edition

o Imām Ad-Dhahabī, Siyar A'lām An-Nubalā, Muassasah Ar-Risālah, Beirut, 1985, Second Edition, verified by Shuaib Al Arna'ut

o Imām Ibn Manẓūr, Mukhtasar Tarīkh Dimashq li Ibn 'Asākir, Dār Al-Fikr li Aṭ-Ṭabā'ah wa At-Tawzī' wa An-Nashr, Damascus, 1984, First Edition

THE TRACING QUR'ĀN TEAM

Publisher & Introduction
Ibn Daud

Director of Ibn Daud Books, Leicester, UK

Tracing Qur'ān Content & Design
Azkar Elsheikh Obied

Architectural Designer, London, UK

Cover Design & Design Consultation
Irfan Chhatbar

Director of Brandboard Creative, Leicester, UK

Qur'ān, Ahādīth & Scholarly Referencing & Translations
Mawlānā Amaan Muhammad

Graduate of Darul Uloom Leicester, and student of Shaykh Ayyub Surti, Leicester, UK

Editing
Mustafa Abid Russell

Leicester, UK

Contributions
Ammaarah & Muhammad Ali Parekh

University & Primary School Students, UK

May Allāh 🕸 compensate the team abundantly with the best of rewards in both worlds.

Āmīn.

Ibn Daud Books are delighted to present to you 'Juz 30' of the 'Tracing Qur'ān Series'.

In this Series, pretty much anybody with the enthusiasm to pick up a pen will be able to unearth the inner workings of the Qur'ān and its deeper treasures. Through tracing the verses, they will gain the tools to appreciate the Qur'ān and its teachings in a lasting personal way.

In a detailed yet simple manner, the enthusiast will also gain an understanding of the Qur'ān as they trace; Ibn Daud Books have included a comprehensive translation alongside a word-for-word translation.

Practice sheets and checklists are provided to help the user track their progress and make solid preparations towards creating their own beautiful copy of Juz 30.

This is a stimulating journey, and its starting point rests on using the pen, the very instrument that Allāh Almighty ﷻ places centrally in His first Revelation to the Prophet Muhammad ﷺ:

"Read: Your Lord is most Generous, He who taught by the pen, taught man that which he knew not." [Surah Al-Alaq 96:3-5]

In using 'The Tracing Qur'ān' methodology, we can give the pen its rightful position as a medium of peace and guidance.

As Anas ibn Malik ﷺ used to tell his son: "O my son! Secure knowledge by writing," [Al-Ḥākim 361] so it will be that a certain security of knowledge and lasting sense of reward will come to all who join us in this subtle and splendid hands-on engagement with the timeless truths and miracles of the Blessed Qur'ān.

'Uthmān ﷺ narrated: The Prophet ﷺ said, "The best among you (Muslims) are those who learn the Qur'ān and teach it." [Ṣaḥīḥ Al-Bukhārī, 5027]

ISBN 978-1-83804-928-7

9 781838 049287